digital masters:
travel photography

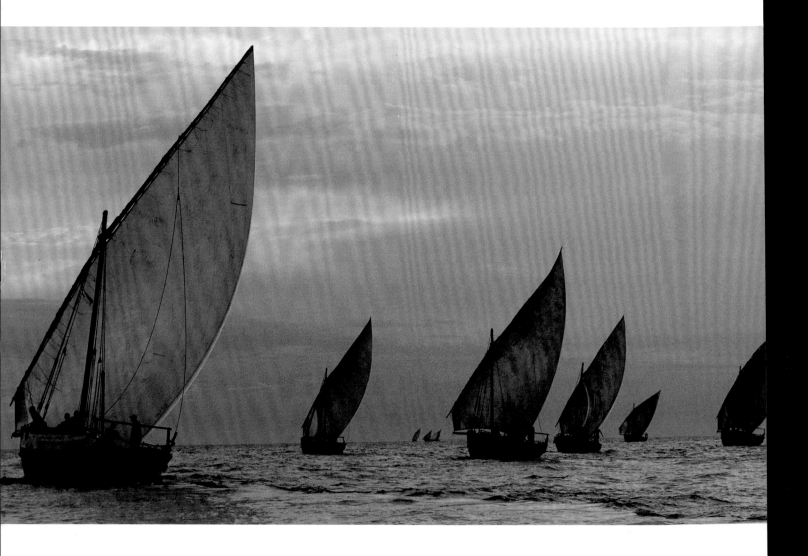

Digital Masters: Travel Photography
Documenting the World's
People & Places

by Bob Krist

LARK BOOKS

A Division of Sterling Publishing Co., Inc.
New York / London

Editor: Kara Helmkamp
Book Design: Tom Metcalf
Cover Design: Thom Gaines

Library of Congress Cataloging-in-Publication Data

Krist, Bob.
 Digital masters : travel photography : documenting the world's people and
places / Bob Krist. — 1st ed.
 p. cm.
 Includes index.
 ISBN-13: 978-1-60059-110-5 (PB—pbk. w/ flaps : alk. paper)
 ISBN-10: 1-60059-110-8 (PB—pbk. w/ flaps : alk. paper)
 1. Travel photography. 2. Photography—Digital techniques. I. Title.
 TR790.K746 2008
 771—dc22
 2008004717

10 9 8 7 6 5 4 3 2 1

First Edition

Published by Lark Books, A Division of
Sterling Publishing Co., Inc.
387 Park Avenue South, New York, N.Y. 10016

Distributed in Canada by Sterling Publishing,
c/o Canadian Manda Group, 165 Dufferin Street
Toronto, Ontario, Canada M6K 3H6

Distributed in the United Kingdom by GMC Distribution Services,
Castle Place, 166 High Street, Lewes, East Sussex, England BN7 1XU

Distributed in Australia by Capricorn Link (Australia) Pty Ltd.,
P.O. Box 704, Windsor, NSW 2756 Australia

If you have questions or comments about this book, please contact:
Lark Books
67 Broadway
Asheville, NC 28801
(828) 253-0467

Manufactured in China

ISBN 13: 978-1-60059-110-5

For information about custom editions, special sales, premium and corporate purchases, please contact Sterling Special Sales
Department at 800-805-5489 or specialsales@sterlingpub.com.

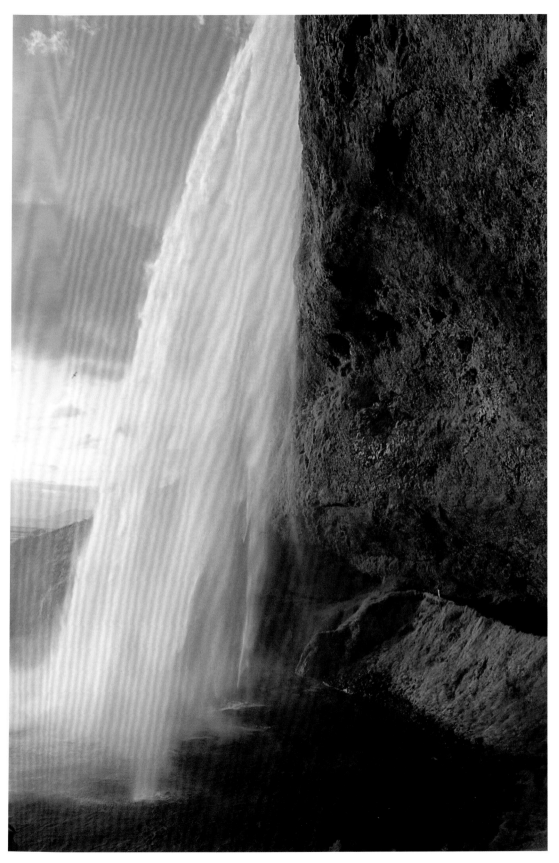

Dedication: For Jonathan, always in our hearts

contents

Documenting our World

There's an old story that Alfred Eisenstaedt–the famous *Life* magazine photographer often referred to as the "father of photojournalism"–used to tell with great relish and amusement. A man and his teenage son approached Eisenstaedt at an opening of one of his many museum gallery shows.

"Excuse me, Mr. Eisenstaedt, but these photographs are magnificent," the man said. "May I ask what kind of camera you used?"
"A Leica, usually," Eisie replied.

The man turned to his son and said proudly, "Son, I'm going to buy you a Leica camera, so you can take pictures just like Mr. Eisenstaedt!"

The story is funny and telling on so many levels. First, there is no other art or craft that you can name where so much of the success of the final product is credited to the tools and not the craftsman. Can you imagine asking a writer at a book signing what word processing program he uses, or asking a painter what brand of oils he favors? Or the idea that a "Chopsticks" level piano player who buys a Steinway will become a better musician? Probably not–the very notion seems absurd.

Yet how many times have you heard a variation of the following: "This camera takes great (or lousy), pictures!" It's such a common idiom that most people don't even realize they're actually crediting the camera–not the person operating it–with taking the picture. Since photography requires a lot of tools to get the job done (camera, lens, printer, flash etc.), those tools take on heightened importance.

This was true enough in the analog age, but the advent of digital photography has only further mystified and, on the surface, heightened the importance of the tools over the craft. Now we have a truly arcane and revolutionary technology that is, for some, so inscrutable that it takes on mythic power and importance.

In fact, there's a general perception out there that digital photography is a panacea, making bad photographers (and their pictures), good, and good photographers great. That, I can assure you, is truly a myth. No matter what medium you use to capture the image, you still need the eye, the experience, the hard work, preparation, and, yes, even some plain ol' good luck, to make a strong photograph. To borrow an acronym from the computer age, photography, even digital photography, is subject to the GIGO principle: Garbage In, Garbage Out. Sure, some post processing skills may help you bag up the garbage and take some of the stink away, but you still need a good product to start with. What this book attempts to do is demystify the digital aspect of making beautiful images while reinforcing the craft aspects that all visual arts require–the "vision thing," to borrow a phrase from one of our past presidents.

We'll look at the subject from each of three stages. The first section explores the basic technology aspects of digital photography as it relates to capturing photographs of places and people on location. The second section covers the aesthetics and logistics of landscape and people photography–how to capture the essence of your subject–in terms of field practices. And finally, the third section explores the myriad of ways you can share your work and tell a visual story using digital technology.

Keep in mind that this book is mainly about the field craft of digital photography and the technology you can use to share your results; it is not a how-to manual. Since the advent of digital photography, there have been scores of books dealing with Photoshop, yet only a few that explore how to handle digital in the field, and what to do after you've done your Photoshop processing. This book aims to fill that gap.

Have No Fear

No new photographic technology that has arisen in my 30-year career has engendered more fear, misconceptions, anxiety, and excitement than digital photography. It has taken the amateur snapshot market, and especially the professional photography world, by storm. Digital has opened up new horizons, created new opportunities, and given us more control over our imagery than ever before. But it has not eliminated all of our photographic problems. In fact, it has actually created as many problems as it has solved.

But that's nothing to be afraid of; good photography has always been about problem solving. Now you just have a choice of which set of problems you'd prefer to deal with; those presented by film or those presented by digital capture. Since you are reading this book, you've picked digital capture for your medium. If you've migrated from film, you'll find a lot to love about the new medium and probably a few aspects of it that drive you crazy.

My transformation from film to digital wasn't easy. For me, the world of working with color slide film was familiar and safe.

The system wasn't broken, as far as I was concerned, so why did we have to "fix" it by introducing a whole new medium for capturing imagery? I was already spending enough time in front of a computer, why would I want to spend more?

In fact, in the early years of digital photography, the only thing propelling me along was industry pressure. It was clear that my specialty, the world of editorial and stock photography—magazines, books, and newspapers—was hurtling towards a digital workflow, and if I wanted to keep current in my career I'd have to become digitally literate.

The early stage of any new technology is difficult, as industry standards and practices are not yet in place and are taking shape and changing with each passing week. It makes it tough for the vanguard of early adopters (some of whom, truth be told, thrive on the chaos) to keep up with the ever-shifting digital sands.

I was one who didn't really enjoy being on the "bleeding edge" of the technology. I much preferred (and still do) to be out making pictures rather than in my office upgrading software or massaging images. But the combination of the passing of time, the maturing of the technology, and my growing familiarity with it eventually made it possible for me to make the switch.

Even now, digital photography can't really be called a "mature" technology, but it has reached a point where you can actually develop a workflow or buy a camera that won't necessarily be outmoded by the time you break the shrink wrap on the box it comes in.

What digital photography offers that film didn't, however, is a staggering array of technology options and methods of capturing, manipulating, archiving, and sharing images. In the film world, the tech decisions were simple: you basically chose the brand of camera you wanted, the type of film you shot, and the lab to which you sent your masterpieces. That was it.

Now, you not only have to choose the brand, but the megapixel count of your camera's sensor. Do you shoot JPEG, RAW, TIFF, or all of the above? Which browser, which image manipulation program, what catalog system? How do you backup your work, archive it, and interpret the files? The list is seemingly endless.

In the digital age, as in the film era, you have to keep in mind that there is no one right way to do it. There are dozens—maybe hundreds—of ways to skin the digital cat. This choice puts extra responsibility on you, the photographer, to research the methods. It can be hugely time consuming and full of pitfalls, a process that intimidates and doesn't really appeal to the large majority of photographers (unless, of course, you've discovered your "inner geek!").

Or, you can take the advice of those who have lived on the bleeding edge for a while, have the scars, and a workable system, to prove it. That's what this book is about: to share an aesthetic and digital workflow system that has worked for me, and could easily work for you as well. I'll be keeping the advice as generic as possible, so you can customize it to your liking. Keep in mind if I mention a camera, piece of software, a computer, or whatever, that you do not have to have the exact same gear to make this work.

The methods that I'll suggest are agnostic; that is to say they're brand-blind. For the convenience of writing and example, I will primarily cite the specific gear and software I use.

But remember, my way is but one way, and my choices are among the many "right" choices you can make as far as gear and software are concerned. The gear you use really doesn't matter, because no matter what the technology is or how it develops, it has always been, and will always be the photographer who makes the picture.

1

gearing up

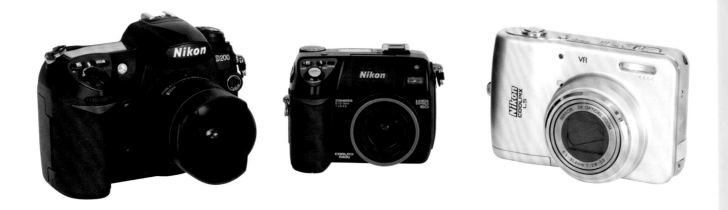

The Camera

Point-and-Shoot Cameras

The appeal of a compact camera that can take stunning images—enlargeable to an 11 x 14 inch print (27.9 x 35.6 cm) and beyond—is huge. It seems the capabilities of digital point-and-shoot cameras are increasing monthly, but there are a few limitations you should be aware of.

The first consideration to keep in mind is the size of the sensor. An 8 megapixel (MP) compact camera sensor is not equivalent to an 8MP digital single-lens-reflex (D-SLR) camera's sensor. True, both sensors have 8 million pixels, but the compact camera's sensor is physically smaller than the D-SLR's sensor. This means that the smaller sensor is inherently noisier than the larger sensor. ("Noise" is the digital equivalent of film grain.) So, while an 8MP compact camera may produce beautiful images at lower ISOs, those images can get very noisy at ISO 200 and above.

The second limitation is the viewfinder. These days, many compacts have eliminated the optical finder entirely, leaving you holding the camera out in front of you with two hands and trying to compose from the live-view LCD monitor (some of which, luckily, are nice and large). Most serious photographers see this as an awkward way to compose and shoot. Optical viewfinders on a compact camera, if they're available at all, are often small and inaccurate for framing a shot.

The third consideration is that the small zoom lenses on these cameras are slow, meaning the maximum apertures are not as fast (f/2.8 is considered a fast aperture because it allows the most light to hit the sensor once, thus this needing a faster shutter speed to make a correct exposure). So you may have a compact camera that boasts a 38-300mm lens coverage, but by the time it's zoomed out, the effective maximum aperture

is f/8 or slower. This causes the camera to use longer shutter speeds, creating camera shake issues (some of which can be corrected with Vibration Reduction or Image Stabilization technology) or subject movement.

The fourth drawback is the lack of wide-angle capacity with a point-and-shoot camera. Most models begin their zoom range at a 38mm equivalent, which is practically a normal length lens in terms of coverage! The rare compact camera will go down to 28mm wide-angle coverage, but these are few and far between. I'm not entirely sure why the wide-angle range has been all but neglected on hundreds if not thousands of digital point-and-shoot cameras, but it is, and for outdoor and travel work, that is a major drawback.

Another limitation to consider is the lack of RAW mode for shooting. Most compact cameras do not offer this desirable feature. Those that do offer RAW file capture take so long to record in that mode that you can have your camera locked up for 6 –10 seconds between shots while the camera writes the RAW image to the card—an excruciatingly long wait.

Finally, the most annoying of all the drawbacks is shutter lag. It seems, at times, as if you could drive a freight train through the space between pressing the shutter release and when the camera focuses and takes the actual picture. This shutter delay is endemic to compact cameras (some are better than others), but in the end it is what drives more people to upgrade.

Although it may seem I'm down on compact digital cameras, nothing is further from the truth. At this writing, I own and use four different models! But you have to have realistic expectations of what these cameras can and cannot do: they don't do sports, fast-moving subjects, RAW capture, or low-light photography very well. The models I own all start at 28mm. (One of them, the Ricoh GR Digital, sports a fixed 28mm lens with a very fast shutter release, but no zoom function.)

One of the great advantages of these cameras is the underwater housing options available. It's an inexpensive and lightweight way to dabble in an underwater or around-the-water photography. I've published several pictures shot with a compact camera in underwater housing. But possibly the best and most pertinent "plus" of a compact digital camera is its size. Now, there is no excuse not to have a camera with you when those magic moments occur!

EVF Cameras

The slightly larger class of camera, the hybrids between point and shoots and D-SLRs, are referred to as "EVFs" because, aside from the LCD on the back of the camera, they have an electronic viewfinder. This small screen is not the same as the reflex viewing through the lens of a D-SLR, but it is another small electronic screen—like the viewfinder of a video camera. You still see what your lens is seeing, but there is an ever-so-slight delay that keeps this from being the same "real time" viewing that you get with a D-SLR.

Many EVF cameras have some nifty features—swiveling LCD monitors and/or viewfinders, wide zoom range, and fairly fast lenses (some with Image Stabilization). Most EVFs have smaller sensors than D-SLRs, but just as many megapixels. Since the lens is attached permanently, you never have to worry about getting dust on your sensor (as can happen when you change lenses on a D-SLR). EVF cameras are usually, but not always, a bit smaller and less expensive than a typical D-SLR with a similar range zoom lens attached. Some EVFs offer RAW format, but the write times for the RAW files are as slow as compact cameras.

Most of these cameras, however, still suffer from the dreaded shutter delay, and when you combine that with the slight delay that you get seeing the image on the camera's LCD or EVF, you've got a problem shooting fast-moving action.

EVF cameras are a good choice for many folks who don't want to carry and fuss with accessory lenses and the paraphernalia associated with D-SLRs, aren't bothered by the grainy "video" display in their eyepieces, and aren't interested in shooting RAW.

D-SLRs

The digital single-lens-reflex camera is the top choice of most photo enthusiasts. Unrivaled in flexibility and features, the D-SLR eliminates shutter lag, shows you exactly what you're getting, and has a huge range of lens options and sensor sizes available. Prices and sizes are shrinking for entry level D-SLRs to the point that they are often in the same price range as an EVF camera.

When shopping for a D-SLR, there are a couple of questions to keep in mind. The first is how many megapixels do you really need? At the moment, D-SLRs run from 6MPs up to 16MPs, with larger megapixel sensors rumored to be on the way. Unless you're a professional who shoots billboards full time, you won't need the camera with the most megapixels. You can save a lot of money (and weight) if you realistically evaluate your resolution needs.

I made spectacular 24 x 36 inch (61 x 91.4 cm) prints from my first D-SLR, a Nikon D70 with a 6MP sensor. Indeed, the *National Geographic's* digital guidelines call for photos made from D-SLRs of 6MPs or more. Many stories shot for that magazine when digital was first introduced were from 6MP cameras.

I had a cover shot published for *National Geographic Traveler* magazine that was one third of a horizontal D70 frame cropped to a vertical, and even that image was still acceptably sharp.

So you don't necessarily need to drop big bucks for a top-of-the-line D-SLR in order to be considered a "serious" photographer. Mind you, having more megapixels means you can crop a bit and still get large, sharp images. And some features of the absolute top-of-the-line D-SLRs—rapid firing rates, huge buffers that allow you to shoot almost continuously while writing large image files to the memory card, tank-like, weatherproof construction to facilitate shooting in adverse conditions—might be important enough that you decide to buy a top-of-the-line camera. But keep in mind that merely buying the best camera will not make you a top-of-the-line photographer!

As a professional with 30 years under my belt, I've always preferred a smaller, lighter camera body. I like to work with two matching D-SLRs, each mounted with a zoom lens—one wide angle, one telephoto. Even though I can afford the big, top-of-the-line Nikon D-SLR, I prefer to work with a smaller Nikon camera body. The slightly smaller sensor is more than enough for any of my needs, and it is rugged. This is very important, because I work in some rather dicey weather and travel conditions. The fact that two smaller D-SLR bodies weigh about as much as one pro models appeals to my aching spine, and that I can almost buy two for the price of one pro model doesn't hurt either!

Working with smaller, less expensive camera bodies not only gives you the luxury of a spare body should you desire one, but it also leaves some money left over for another important purchase: lenses.

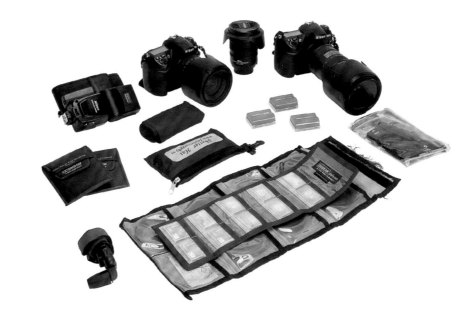

On the Road:
Full-Frame vs. APS-Sized Sensors?

The camera sensor's physical size—not just its megapixel count—may also play into your decision to buy a D-SLR, as well as help you determine what kind of D-SLR will fit your needs. One benefit of the full-frame sensor (also called a 35mm-sized sensor because it is the same size as a 35mm film negative) found in some high-end D-SLR cameras is that your old film lenses will work in the same way they did, giving you the same degree of coverage. The larger sensor also shows less noise at high ISOs than the smaller, APS-sized sensor found in other D-SLRs.

Advocates of the APS-sized sensor point out that because light must hit digital sensors straight on and not at an angle, the corners of full-frame sensors may not capture the corners of an image as sharply or as bright as they should. The smaller sensor makes it easier for lens designers to take special care that the light rays entering the lens hit the smaller sensor less obliquely in the corners, yielding better results. But with APS-sized sensors, you often have to multiply the coverage of your lenses by 1.3 – 1.6x, depending upon your camera's make and model.

Thus, a 100mm lens becomes a 150mm on such a camera. And a 28mm becomes almost a 50mm, so makers of smaller sensor D-SLRs, like some Nikons and, some Canons, and most other brands had to come up with ultra wide-angle lenses to cover the wide end of the lens spectrum. To get the same range of coverage on my APS format camera as the 17-35mm zoom lens gave me on my film cameras, I use a 12-24mm Nikkor zoom lens.

The Accessories

Lenses

The digital revolution has changed a lot of the rules of photography, but some of the laws of optics and how they work are immutable. With the advent of the smaller, APS-sized sensors, many of the lenses for D-SLR cameras have become somewhat smaller as well. Many manufacturers have begun to offer "zoom" focal length lenses; that is, one lens that covers a range from wide angle to telephoto.

It's not uncommon to see 18-200mm lenses (in 35mm parlance, this would be the equivalent of a 24-300mm lens). This is a huge range of coverage, and it is very tempting to think that you can replace a bagful of lenses with one compact optic that will do the job. However, it's important to remember that there are tradeoffs for the size and convenience of these lenses. Some photographers are willing to live with them, and some are not. In the world of optics, if you want speed (or light gathering ability) and sharpness, you are looking at larger, heavier lenses and

smaller zoom ranges (or even no zoom at all, but a fixed focal length). A 17-55mm f/2.8 lens, paired with, say, a 70-200mm f/2.8 is a pair of large, hefty lenses. An 18-200mm variable aperture zoom might start at an f/4 and change to an f/5.6 at the long end, but it will be smaller than either of the other two. Also, it may not be as sharp as either of those lenses, because in order to achieve that range, the zooms lens might have two to three times the number of glass elements; that usually means more lens flare and softer corner-to-corner sharpness at extreme focal lengths.

It is still the same old tradeoff: size and weight vs. speed and sharpness; slower speed and softer sharpness for lightweight convenience. It's up to you to determine which means more to you, and truthfully, the quality of some of the zoom lenses has reached the point that they are eminently useable for most situations.

Several independent lens manufacturers are taking advantage of the smaller APS-sized sensor to make smaller, but faster, lenses. Sigma and Tamron have 18-50mm f/2.8 lenses that are about half the size and weight of the original equipment lenses with the same focal length range. Similarly, Tokina and Sigma have shortened the telephoto range to 50-150mm and 50-135mm f2/8 lenses, giving us lenses that are half the size and weight of the big (and popular) 70-200mm f/2.8 zooms. With the APS sensor's 1.5x magnification factor, their coverage is slightly longer than the 70-200mm lenses are on a camera with a full-frame sensor.

So a photographer with an APS-sized sensor D-SLR—wanting fast yet relatively compact lenses—has more choices than ever. Either way you go, a uni-lens or fast zooms, a coverage range of 24mm–200mm (in 35mm parlance) or 18mm–150mm is probably the minimum range of coverage you'd want for most outdoor and travel subjects.

While most of the digital revolution has centered on the new medium, the camera manufacturers also vastly improved and revolutionized their flash systems. The ability of the camera and flash to blend available light and flash exposures for easy, natural looking pictures has been a feature of most flash systems for a while now. It's all controlled automatically, through the lens, and it makes fill-flash and other flash techniques, once the providence of experienced professionals, available to just about everyone.

Since many D-SLRs and EVF cameras have built-in flash units, you may be asking yourself, "Do I really need another flash unit for travel work?" The answer is a resounding "YES!" The reason is fairly simple: the onboard, pop-up flash is too small to be truly useful for anything but simple, up close fill flash situations, and its placement so close to the axis of the lens almost guarantees the dreaded "red eye" in subjects photographed in dark conditions. It's a great little backup flash in case you forget or break your bigger, shoe-mount flash unit, but it is not up to being your main or only flash source.

Red eye is caused by the flash reflecting off the blood vessels in the retina of the eye. The more the pupil is dilated (as in dark conditions), the more of the retina shows. For the reflection to occur, the angle of entrance of the light from the flash has to be very close to the axis of the lens. The closer the flash sits to the lens, the more chance you have of those ghostly red eye reflections. Since the pop-up flash on most D-SLRs and EVFs (and all compact digital cameras) sits right above or next to the lens, this is common.

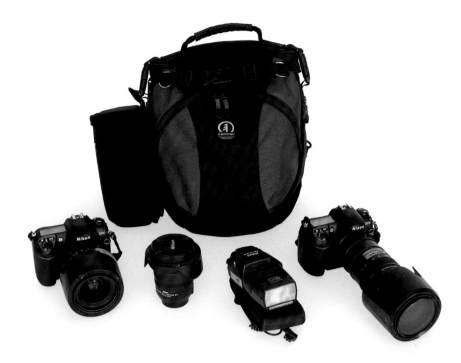

But despite the negatives of a pop-up flash—namely weak output and poor placement—there are very strong reasons to buy a D-SLR that has one. In most cameras, these units can be programmed to control an off-camera flash unit via infrared pulses. In my Nikon D-SLR'S, I can program the onboard flash to put out only invisible infrared pulses that will cordlessly control the output of a remote flash with full through-the-lens (TTL) technology. This is an amazingly convenient and powerful feature. We'll discuss flash use in detail in Chapter 6.

Tripod

There is a school of thought that says—aside from there's no such thing as being too rich or too thin—there's no such thing as having too big and sturdy a tripod. Not knowing what either rich or thin would feel like, I can only speak with authority on the third desirable, that of the gigantic tripod.

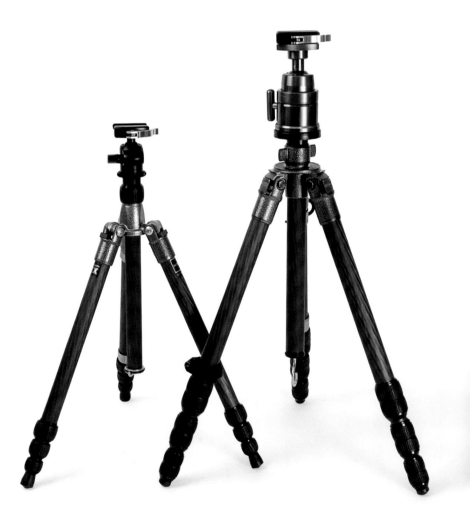

In an ideal world, a big, rock-solid tripod ensures maximum sharpness from your camera and lens. It's something we all strive for, and it's why we buy the very best gear we can afford. That ideal world, of course, would include someone to carry that giant, heavy tripod for you at all times to prevent fatigue and back strain. It would also include a world where airlines didn't care how much your luggage weighed and museums, municipalities, and other authoritative organizations would not restrict the use of tripods in their facilities.

That's not the world that any of us live in (unless you're too rich!), so my tripod philosophy is more utilitarian. I'll take the biggest tripod necessary to do the job. Fortunately, in the era of new alloys and materials like carbon fiber and basalt, as well as some of the new leg lock designs from Gitzo and other manufacturers, you don't need a big heavy tripod to insure stability—the new designs and materials are proof that "lightweight" does not automatically equate with "flimsy."

I currently use one of two small carbon fiber tripods with small ballheads. One rig weighs about 4lbs (1.8kg), the other about 6lbs (2.7kg). I find myself reaching for the smaller one time and time again, because another one of my tripod truisms goes something like this: Which is better, the heavier tripod you leave back in your hotel, campsite, or car trunk, or the lighter one that you actually carry with you?

Making your tripod easy to carry is another way to insure that you'll actually use it. Too many folks sling the thing over their shoulders, devoting one hand and one shoulder to carrying the tripod, making it slow and awkward to actually shoot a photo. I've designed a simple, homemade tripod strap that allows the tripod to be carried over one shoulder, and doesn't require removal when you actually want to use the 'pod.

On the Road: Hands-Free Tripod

Making a homemade sling strap for hands free carrying of your tripod is a pretty easy task. I'm completely useless with most DIY projects, but this one is do-able, even for me. You will need two Fastex D Rings—the 1/2-inch size (available at camping supply stores or on the web from www.campmor.com), some gaffer's tape (like duct tape, but features a strong adhesive that won't leave smears and residues when it's removed; available at professional photo shops, stage lighting stores, or on the web), and an old camera strap.

With your tripod legs folded up, tape one of the D rings, flat side against the leg, near the top of one leg section where it connects with part of the tripod that holds the head. Loop the tape through the ring several times, with the curved portion of the D Ring sticking straight out. On the lower portion of that same leg section, tape the other D ring with the curved portion facing out.

Clip an old camera strap to the D rings, and you've got a sling strap for your 'pod that allows you to carry it hands-free and shoot handheld until you need it. You never have to remove the strap to open the tripod.

The best (and least straining) way to carry it is with the tripod head pointing down and in front of you. If you carry it any other way, you put undue stress on the rings.

If your tripod legs are loose, and you find the tripod legs pulling away from each other as you carry the tripod this way, simply slip a rubber band around the tips of the legs to keep them together. Well-adjusted tripod legs will stay together even if the weight of the tripod is being borne by just one.

Look for a tripod that has a hook on the bottom of the center column (several Gitzo, Slik, and Hakuba models feature this hook). Although the tripod itself may be lightweight, hanging your camera bag on this hook will instantly give you the added weight and stability you may need in certain situations. The hook allows you to make use of the weight you are already carrying (i.e., the camera bag) instead of carrying additional weight in the form of a huge tripod.

Sensor Maintenance

One new problem digital photography has introduced is the accumulation of dust on our D-SLR sensors. When the mirror in your D-SLR flips up, this sensor is struck by light and records the image. But when you change a lens, or work in very dusty environments, dust can make its way past the mirror and come to rest right on the sensor.

Dust on the sensor results in dark spots in your photographs. These spots are often unnoticeable until you have a picture that includes a large light area—say a clear blue sky in a landscape shot—and then you may see the dark spots. The smaller the aperture used, the more prevalent these spots can become (because of the added depth of field). If the spots appear in the same place in the frame from picture to picture, you've got the dreaded problem of dust on the sensor.

The best way to deal with dust on the sensor is to try to prevent it in the first place. Good lens-changing practices can help. Always turn your camera off before you remove a lens; this removes the "charge" from the sensor, making it less of a dust magnet. Always have your replacement lens ready to bayonet on, and make sure you get out of the wind as much as possible before you begin the operation.

Dust on the sensor, however, is inevitable. So what can you do when it occurs?

The first step is to read your camera manual carefully for instructions on how to clean the sensor. Many new D-SLRs come with in-camera sensor cleaning technology (the camera "sees" the dust and processes it out of the images as they are written to the memory card), or have a sensor vibration feature that powers the sensor down to remove its electrical charge and vibrates it quickly to dislodge dust particles.

Not all D-SLRs have automatic dust removal features, but do allow for manual cleaning. This usually requires a fully charged battery or an AC adapter, and a mirror lock-up provision while the camera is powered off. This gives you access to the sensor without its static draw for dust.

Most loose dust can be blown away with air from a large bellows blower brush such as the Giottos Rocket Blower. Several mighty puffs from this will dislodge all but the most stubborn dust. Do not touch the brush bristles to the sensor unless the brush is specified for sensor cleaning. (Do not use canned air, it has blower propellants that could damage the sensor.)

Consult your camera manual for instructions when cleaning the camera's sensor. It is important that you power down the camera to remove the sensor's electrical charge when you attempt to clean it. There are several effective methods for removing dust from the sensor. A rubber bulb blower works well for minor dust problems, but a cleaning solution and swabs specially designed for sensor cleaning might be necessary for more difficult sensor dirt.

If the blower doesn't work, your next approach is to use a specially designed sensor brush to physically remove the particles from the sensor. These brushes are specialty affairs with bristles that are gentle enough to not scratch the sensor, but, when "charged" by blowing them with air or rotating them quickly, seem to actually attract the dust as it sweeps the sensor. I use a contraption whimsically called "The Arctic Butterfly" from a Canadian company called Visible Dust (www.visibledust.com) for this. It has a battery operated handle that can spin the brush very quickly to build up the charge. (Note that you never, ever, put the spinning brush into your camera to clean the sensor—you just charge the brush that way—it is always used with the spinner turned off).

If these methods fail to dislodge the dust, or if your problem is more like a smear than a piece of dust, the next level of cleaning involves wet swabs. This is an extremely delicate operation, and requires special fluid and dedicated swabs. Visible Dust and two other companies, Copper Hill Images (www.copperhillimages.com) and Photographic Solutions (www.photosol.com) offer the swabs and the fluids as well as the dry brushes.

Because of the delicacy of this operation and my own tendency to be hamfisted, if my sensor is this dirty, I usually send the camera back to Nikon to be cleaned. I just don't trust myself not to goof up this operation, and truthfully, I haven't had too many bad dust problems because I'm extremely careful in the field when it comes to changing lenses.

Of course, you may be handier than I am, but if you undertake cleaning your own sensor, take advantage of the myriad of tutorials on the subject on the websites of the cleaning supply providers mentioned above, and remember, it's done at your own risk!

Shooting Strategies: RAW or JPEG?

There is much confusion over shooting RAW versus shooting JPEG. JPEG is a compressed file format, processed in-camera, and can be used directly from the memory card without further need for post-processing. RAW format is simply the pure information captured by the sensor without being processed into a usable file type like or JPEG.

Since there is so much RAW information, there is a large amount of latitude in terms of color balance, exposure, contrast, sharpness, and more in a RAW file. With JPEG, the camera has already taken that information and processed it into the file format. You can make some changes after the fact in exposure, color, and contrast—the only difference is that with each manipulation, you are eroding the image file and throwing away pixels and information, resulting in a less complete file. Apply several big changes to a JPEG image file in a photo-editing program, and you've got a file with gaps where there should be pixels and a picture that may not print or reproduce as well.

Some people find it helpful to think of JPEGs as analogous to color slides; you have to be technically very accurate at the moment of exposure because what you shoot is what you get, and you can't really change too much after the shutter is tripped. RAW, on the other hand, is similar to shooting color negative film. In and of itself, most viewers can't view the negative, but that negative contains so much information and latitude that you can easily change the color balance, exposure, contrast, and so on. Those changes are presented only in the final form of the negative that you will share.

Gauge your preferences to determine which is the format for you. There is a school of thought that says that RAW is the only way, that the quality of the picture is so much better, and that JPEG is basically a four letter word. That seems a bit extreme.

For most users, JPEG is just fine, and if you shoot a JPEG file that is not heavily compressed, you can open and close JPEGs over and over with very little—if any—quality loss. JPEGs take up less space on your CompactFlash (CF) or SanDisk (SD) card, and later on your hard drive.

If you are a careful shooter with good technique, JPEGs are more than serviceable. Indeed, many of the photos you see in newspapers and magazines were shot as JPEGs. Many digital photography internet forums and blogs make it seem that RAW is the only way to go, and if you're not shooting in RAW then you're not really shooting. That is not necessarily the case: if you prefer the simpler workflow of JPEG, use a larger JPEG/less compression file choice on your camera, and make the correct settings for exposure and white balance, there is no cause for a JPEG shooter to feel like a second class citizen.

As you gain experience in digital photography, and RAW conversion programs become easier and more user-friendly, RAW may indeed be in your future. I resisted it heavily when I first started shooting with digital equipment. I didn't want to spend any more time in front of the computer than I absolutely had to. However, with some practice, I eventually became adept at quickly converting large numbers of RAW files to JPEGs, and began to enjoy the added latitude and benefits of shooting in RAW.

On the Road: Which RAW Converter is for You?

Every camera manufacturer offering a camera with RAW file capture also makes a RAW conversion software (as do many independent companies like Adobe, Bibble, Iridient, and Capture One). Photographers are as passionate about their RAW conversion software as sports fans are about their favorite team. Everyone swears that their choice is the only choice and that all others are somehow second class.

The result is that—as with a lot of digital photography advice—it becomes hard to make sense of the myriad of voices. Keep in mind that in digital photography, as in life, there is more than one way to arrive at a destination or achieve the result you desire.

There is no one "correct" way and if you choose one method over the other, you are not necessarily wrong, you have just chosen a different path to get to your desired result—a nice looking JPEG or TIFF.

There are several things I'd look for in a RAW conversion program:

• Friendliness of its interface. It is important to be able to understand your options easily. RAW conversion programs offer so many levels of control that it is easy to get carried away in the minutiae of micro adjustments, and the interface begins to look more like it belongs in a nuclear physicist's laptop than a photo enthusiast. There is a learning curve associated with any RAW converter, but if it seems like you need a PhD in physics to understand yours, it might be time to look elsewhere.

• The ease of batch processing. If you shoot a lot of images, you want a program that makes it easy to "gang process" a number of RAW files that you've adjusted into JPEGs or TIFFs. Some programs are better than others in accomplishing this.

• Remember that you don't have to choose just one! After discovering the strengths and weaknesses of the myriad of RAW converters out there, many experienced shooters have more than one converter on their hard drive, and will use the one most suited to the particular file. For instance, I use Adobe Camera RAW as my main converter—probably 95% of the time. It's powerful, easy to use, and has great batch processing options. However, I also keep Nikon Capture NX handy if I run into a file with particularly difficult color balance or contrast. Its control over color and contrast is more finely tuned.

Camera Settings for Digital Photography

Most photographers are already familiar with the traditional controls of the camera, like shutter speed and aperture, and also the automatic modes, like Program, Aperture Priority, Shutter Priority, and Manual. But digital cameras present us with yet another laundry list of options, some of which can be confusing. Let's take a look at some of the main features and what they do.

File Size

By now, you've probably discovered that using the smallest-sized JPEGs your camera offers is a great way to fit a lot of pictures on your recording media, but not if you're interested in anything but web publication. Indeed, selecting the size of the JPEG you'll record should be determined by the usage you intend to make of the photographs. If all you want them for is web use, you can happily shoot away using the small size, low quality JPEG. If you intend to make prints, but nothing larger than 4 x 6 inches (10.2 x 15.2 cm), then the next step up will suffice. If you never go larger than 8 x 10 inch (20.3 x 25.4 cm) prints, then the normal setting will probably do the trick.

The problem is that few people know exactly what the end use of their pictures will be the moment they are shooting them. What happens, for instance, if you're set on low quality, but happen to take a magnificent photograph of, say, a rainbow over some mountains that you'd like to use mural size in your living room? You're plumb out of luck. The file is just not big enough.

That is the reason that most photo enthusiasts shoot at the largest JPEG file size offered by their particular camera. That way, you record as much possible data as your camera can, and you can always size the files down should you want to put them on the web or make small prints. Going smaller is never a problem. With the price falling almost weekly on recording media like CF and SD cards, memory is one of the cheaper components of digital photography, so why not shoot the very best quality files your camera can record? It just makes sense.

There's another, less obvious choice you need to make about image size—the amount of compression your camera uses on image files. JPEGs are compressed every time they are closed, and some information is lost. The more compression you apply, the smaller the closed JPEG file will be and the more of them you can fit on any given sized memory card or stick. But again, a highly compressed file means you're paying the price in quality loss. The more compressed the JPEG, the more information is thrown away each and every time you open and close the file. After a while, a highly compressed JPEG will begin to visibly lose quality.

So do yourself and your pictures a favor—shoot the largest JPEG your camera offers with the least amount of compression. If and when you do start shooting masterpieces, you want to make sure they'll be around to be enjoyed by posterity!

White Balance

Understanding and appreciating that all light has color is critical to grasping the concept of white balance (WB). The color of noonday sunlight is much more blue than light generated by a bank of candles. Late afternoon daylight is more reddish orange than at midday. Some light sources, like fluorescent lights, don't emit a full spectrum of light and are mainly green! The scale used to measure the color of light is the Kelvin scale. Full midday sunlight is about 6000 degrees Kelvin (6000K), incandescent or tungsten lightbulbs might put out 3200 to 3400K, and candlelight is in the 2000K range.

As film shooters, we had mainly two types of emulsions—daylight or tungsten—and a myriad of color filters to deal with these different color temperatures in order to record accurate color. As digital shooters, though, we can program our cameras to produce good, clean, accurate colors in almost any light because we can change the white balance of the processed image at will.

The easiest way to guarantee getting accurate color is to use Automatic White Balance (AWB) function. With AWB, the camera reads the Kelvin temperature of the light you are working in and adjusts the recorded image accordingly. This way, you will never have the wrong color balance set for the type of light you're working in. But, as many photographers have learned, accurate color isn't necessarily beautiful color! Take for instance, the widely accepted practice of shooting landscapes in early morning or late afternoon light.

True, the shadow patterns at those times are more pleasing, but so is the color of the light. The longest rays in the spectrum are the red ones. Only the longer light rays penetrate the atmosphere when the sun is at its lowest in the sky, and hence we get the lovely warm orange-ish light right after sunrise and right before sunset. The Kelvin temperature of that lovely light could be in the 3000K range. Record this light on daylight (6000K) balanced film, and it reads as we see it—nice and warm and orange. Record this on AWB on your digital camera, and it will "correct" all that warmth and you'll get a neutral, soulless color balance.

Many photographers, therefore, will leave their color balance on daylight for instance, or even "cloudy" (which is designed to counteract the bluish light of a cloudy day) to retain the nice warmth of early morning or late afternoon light. Because I like warm color balance in general, my default WB setting is "cloudy." I like the way it records on sunny as well as cloudy days.

If I go inside, or shoot under mixed lighting (such as when window light and electric lights are both contributing to the available light), I might switch to AWB to make sure I'm in the neighborhood. Again, if you shoot in RAW format, white balance is less of an issue because you can change it after the fact (another strong argument for shooting RAW image files).

You can also use WB creatively to intensify an existing color. For instance, if you shoot during the bluish light of twilight, and set the camera to a tungsten balance (usually symbolized by a lightbulb icon), you'll get amazingly blue blues. The tungsten setting is designed to cool down incandescent light by adding blue to the scene. This is not the "correct" use of color balance, but it can be beautiful.

White Balance/ Kelvin Chart

Light Source	Kelvin Temperature	Pre-Programmed WB Setting
Candles; oil lamps	1000K	
Very early sunrise; low effect tungsten lamps	2000K	
Household light bulbs	2500K	
Studio lights, photo floods	3000K	Tungsten (3200k) Fluorescent (4200K)
Normal daylight; electronic flash	5000K	Sunny (5200K) Flash (5400K)
Bright sunshine with clear sky	6000K	Cloudy (6000K)
Slightly overcast sky	7000K	
Hazy sky	8000K	Shade (8000K)
Open shade on clear day	9000K	
Heavily overcast, Deep Shade	10,000K	

Using the Histogram

Without a doubt, for many users the most mystifying display on a digital camera is the histogram. Basically, a histogram is a graphic representation of the distribution of the pixels in a given image. The left side of the histogram represents the shadows, the middle represents the midtones, and the right side represents the highlights. Ideally, a well-exposed image has enough pixels representing highlights, midtones, and shadows, falling between the extremes, without "clipping" either the highlight or shadow side. Clipping occurs when there are no pixels at all in either the shadow side or the highlight side, and is represented when the histogram hits either side of the graph before it hits the bottom.

A clipped shadow is pure black, without any detail whatsoever. Slide shooters have become accustomed to these blocked up shadows and have learned to use them as graphic elements—shapes and silhouettes—in contrasty scenes. Digital shooters can do the same thing with detail-less shadows. Ideally, your shadow areas should have some detail, but if they don't, it's not the end of the world.

One thing that digital shooters must never do, if at all possible, is clip the highlights. A clipped highlight is completely barren of pixels—pure nothing. It is impossible to bring

out any of the detail if nothing is recorded in the first place. This is true in RAW mode as well as JPEG. So, it is vital that the pixel information in your histogram doesn't touch the right side—the highlight side—before touching the bottom. A few blown highlights, such as the edges of white clouds on a sunny day, won't be fatal to your photo, but large areas of clipped highlights will make a picture almost impossible to print or reproduce well.

Many books show the "ideal" histogram as having three peaks, like a mountain range, all falling neatly between the two extremes of shadow and highlight. I wish that the world we photograph always had such a nice-looking histogram, with an even distribution of highlights, midtones, and shadows. Truthfully, most of the pictures you take probably will not have the ideal histogram. In fact, your histograms will be a confusing array of shapes and angles in many

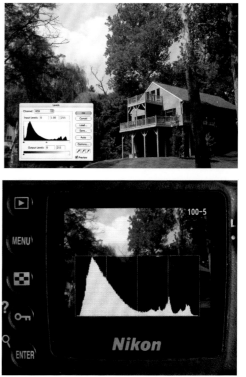

This histogram shows a well-exposed situation. Notice how all the peaks and valleys of the histogram are within the two sides of the graph—they don't run into either side, which would indicate clipped highlight or shadows. It doesn't matter what the shape of the histogram is, as long as that shape hits the bottom of the histogram chart before it touches the sides.

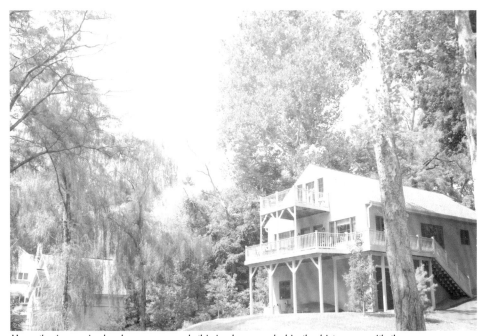

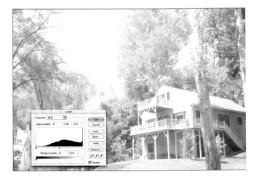

Here, the image is clearly overexposed—this is also revealed in the histogram with the pixels hitting the graph on the right side or highlight side. This indicates clipped highlights—areas where there are not any pixels—and should be avoided. Sometimes, part of white clouds or windows in interiors will "blow out," and there's not much you can do about that. But when large portions of your pictures "blow out"—as the sky has in this exposure—it's correctable.

example A

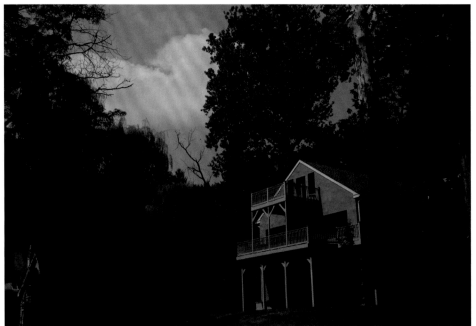

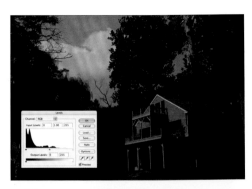

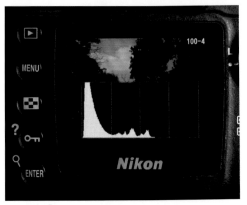

Here, the picture is underexposed, and you can see the pixels hitting the left side of the graph, indicating clipped shadows (areas of black with no detail). In some situations, completely black shadows aren't a problem (shooting something in silhouette, for example). In this case, there are too many clipped shadows, and a proper exposure would reveal them.

example B

situations. A high-key picture, say of a small flower on a sand dune, will have a spike on the right and almost nothing else (see example A). A low-key picture, like a black whale breaching a navy blue ocean, will have one spike to the left of center and little "elevation" anywhere else (see example B). The important thing to remember is to see that histogram graph hit the bottom line before it reaches either side of the (where the shadows or highlights become "clipped"). And if it has to clip one side or the other, clip the shadows before the highlights.

Many camera manufacturers, like Nikon and Canon, offer a "clipped highlight" warning in addition to a histogram because this is such an important issue. In this mode, any highlights that are clipped blink on and off in the image review screen. You then know you should stop down your exposure by one-half or one-third stop. If the resulting picture still has blinking highlights, step it down another half or third stop until you lose, or greatly minimize, the "blinkies."

While overexposure and clipped highlights are to be avoided at all costs, it's not a good idea to regularly underexpose things either. A clipped shadow is not the end of the world, but too much underexposure results in a "noisy" picture. Noise, as we mentioned earlier, is like digital grain. It is made up of multicolored pixels and is especially prevalent in shadows, underexposed areas, and when the camera is used at a high ISO.

There are noise reduction tools and software that you can apply after the fact to minimize the effect of "noise," but the best way to avoid it is to properly expose your images and use the lowest ISO setting possible for the given lighting conditions.

On the Road: Tonal Recognition: Digital vs. The Human Eye

One reason why so many photographers run into exposure problems when shooting is that they don't have a realistic expectation of what the sensor can record in contrasty scenes with both bright highlights and deep shadows.

While the human eye can see a range of about 12 – 14 f/stops, from bright highlight to deep shadow, the digital sensor can only see a range of 5! So you may be able to look at, say, a person wearing a white t-shirt and a baseball cap standing in bright sunlight at midday and see detail in both the brightest part of the white t-shirt and the darkest part of the shadows beneath the brim of the cap. But your camera cannot. It can record one extreme or the other (the deep shadow or the bright white highlight) and clip the opposite end, or it can record the middle tones and clip both the highlights and the shadows. It cannot record the same range of tones that your eye can see.

Why is this important? If you understand the recording range of your digital camera, you'll start to look for picture situations that are well suited to its abilities, and thereby create better pictures. You'll stop trying to shoot dappled sunlight in a rainforest (and being disappointed by the blotchy result), and start looking for even shade or uniform sunlight in which to shoot your pictures. You'll stop shooting pictures of people in deep shade with a bright sunlit background and wondering why you get silhouettes or burned out backgrounds.

By understanding the limitations of your recording medium (and not asking it to do more than it was designed to do), you can create better, stronger photographs. It's likely that someday there will be a sensor that can record exactly as the eye sees, but until that day we have to adjust our shooting style and subject matter to make the best possible photographs.

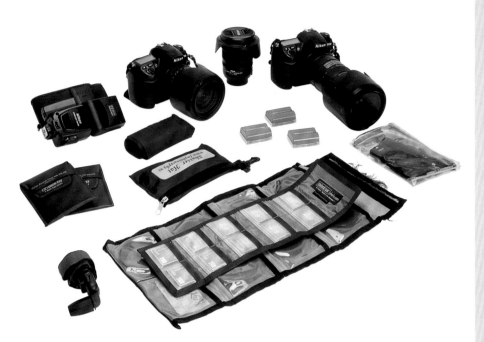

Here's my basic location list:

- 2 D-SLR bodies
- 12-24mm f/4 wideangle, fixed aperture zoom lens
- 17-55mm f/2.8 mid range, fixed aperture zoom lens
- 70-200mm f/2.8 telephoto, fixed aperture zoom lens
- external flash unit with external battery pack
- polarizing filters (Singh Ray LB Polarizer Combo and Gold 'N Blue Polarizer)
- graduated neutral density filters (Singh Ray hard edge, 2 and 3 stop)
- extra batteries for cameras and accessory flash unit
- memory card wallet with either CF or SD cards (depending on the camera)
- small umbrella (for rain)
- cable release
- cleaning cloth
- bubble level
- small headlamp flashlight

The Master's Toolkit: What's In the Bag?

The trick to a location camera bag is that it should contain everything you need and nothing you don't. Now that's a tall order to fill, especially when you throw in carry-on rules of airlines and weight issues for your spine. Here's a brief rundown of what I carry for most location assignments, and how I carry them.

Since most of my work is travel, I want a bag that is accessible from my shoulder. Backpacks are great if you're in the wilderness, but in urban situations, any bag that you have to take off and put on the ground to access is going to slow you down and indeed, might even be dangerous. I can't tell you how many backpack-toting photo students in my workshops bring tales of stuff being lifted from their bags when they turned away from it to make a shot.

All of the above (plus a few other small items) fits nicely into a compact shoulder or sling bag. My two favorite bags are currently the Tamrac Velocity 9X—a sling bag that allows full access to your gear without taking it off your body—and the ThinkTank Urban Disguise 60. Both bags allow you to carry cameras with the zooms attached, and are low profile.

A second bag, usually a ThinkTank rollaboard—the Airport International—contains the computer gear, including:

- Apple MacBook w/ power adapter

- Epson P500 viewer

- 2 80GB bus driven USB/ FireWire mini hard drives w/ one AC adapter

- 2 battery chargers for cameras

- 2 USB card readers

- bulb blower, sensor-cleaning brush, swabs, and cleaning fluid

- miscellaneous retractable cords and adapters

- 120 volt or 220 volt power strip/surge suppressor w/ plug adapters

- nylon photo vest

- digital point-and-shoot camera w/ battery and charger

- Zoom H2 digital voice recorder w/ earphones

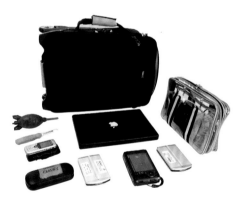

This particular system setup is nicely "redundant," meaning it has nearly two ways to do everything. For instance, if my main laptop should happen to go down, I can still download and view my images on the Epson P5000, which has an 80GB capacity. I don't use this on a regular basis; I carry it only as a backup to my laptop.

One of the perks of this particular Epson viewer is the ability to export information to an external USB drive. This enables me to make two backups of my pictures by copying images from the Epson viewer to the auxiliary hard drives (the only thing the Epson viewer won't do is provide "bus power" to the drives, so make sure to use drives that have a small AC adapter option).

To keep size and weight down as much as possible, I get rid of all standard USB, FireWire, and AC power cords in favor of ones that are on spring retraction devices. It's laughably easy for a bag to become completely stuffed and tangled with standard 2 foot (0.6 m), 3 foot (0.9 m), and 6 foot (1.8 m) wires, so the little retractable versions of these cords saves a whole lot of hassle.

While carrying a powerstrip may at first seem like overkill, the beauty of these is that you only have to find one open plug in your hotel room (believe me, that can be hard enough) and if traveling overseas, you only need one plug adapter (for the strip), instead of one for each item you're plugging in. Since most computers, battery chargers, and the like are dual voltage (or voltage-seeking), all that I need to carry is the strip, not the heavier voltage converters.

These two bags fit the overhead compartments of any plane, regional jet or otherwise, even some of the smallest puddle jumpers, and they fit the "one personal item and one carry-on" requirement of all American airlines and most overseas carriers. If I get nailed mid trip by a strict "one bag" carry-on policy on a foreign airline, I can put all the contents of the computer bag in the pockets of the lightweight nylon photo vest and actually wear the stuff onboard—you won't win any fashion awards, but you won't have to doom your precious and fragile photo or computer gear to the checked luggage hold.

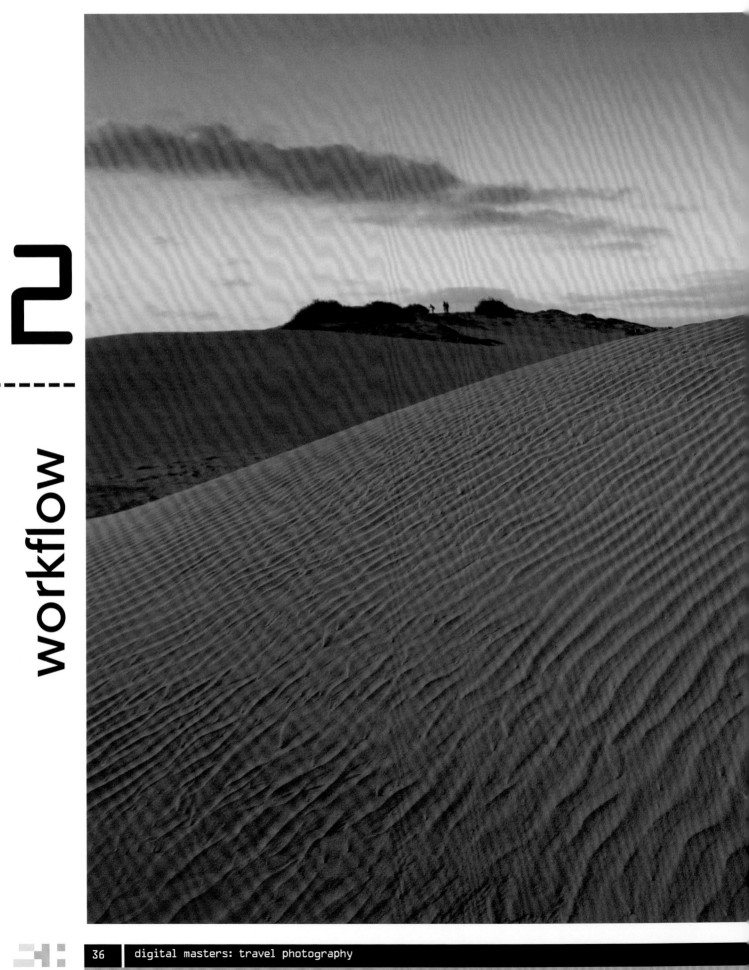

2

workflow

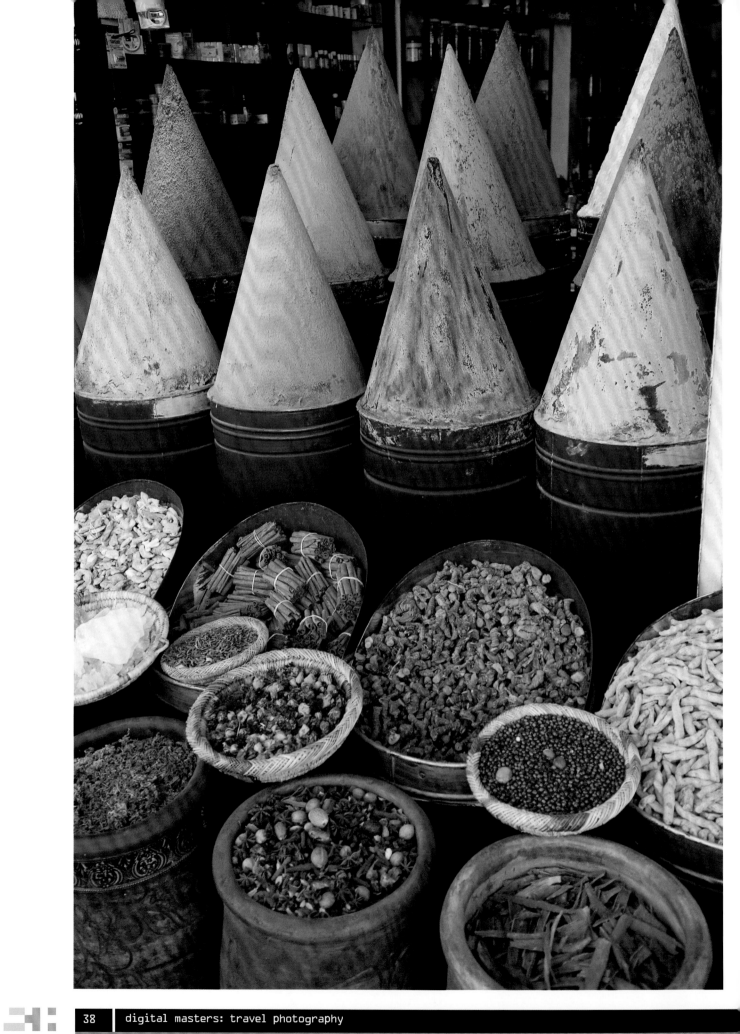

On the Road: Workflow or Work Slow?

Once the euphoria of digital photography—the instant feedback, the lack of film costs, etc.—washes over you in the early stages, realities soon begin to set in. One of the harshest of those realities occurs when you start traveling with your digital camera on multi-day trips away from home, or even if you are staying home but shooting day in and day out. Now, you've got to manage and backup all those wonderful images you're capturing every day, erase your cards, and go out the next day and capture more. On a two week vacation to Europe where you used to simply toss the exposed film in a bag at the end of the night and go off to the restaurant, you now have to download, rename, backup, and maybe even caption your files to be ready for the next day.

Without a workable system with which you are thoroughly familiar, this process, called "workflow" by most (and "work slow" by digerati wags) can be easily overwhelming, and eat up all of your free time—maybe even your shooting time. If you manage to download your pictures but don't rename them or back them up, you're still liable to forget (or lose) images. It pays to have a good workflow.

You'll hear differing and even conflicting advice on workflow—it seems to be one of those things that everyone does in their own particular manner—so it pays to shop around, try different methods, and see which one suits you and your work. There's no single correct way; indeed, there may be several ways that will work fine for you (and some that just won't).

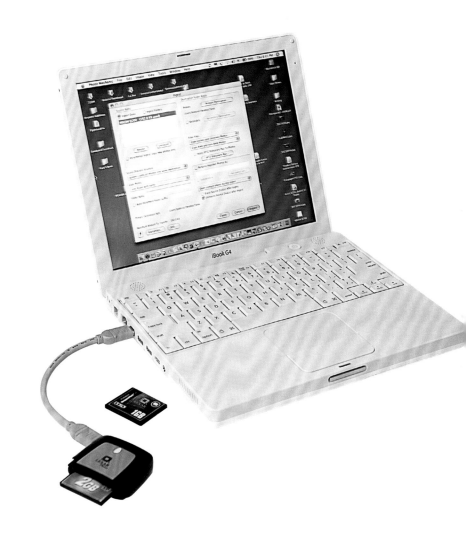

First Steps

Download

The first step in any digital workflow, and one thing almost universally embraced, is to use a card reader to download your images from the memory card to your computer, rather than connecting your camera directly. True, most cameras offer the option to connect directly to the computer, but this essentially networks two very different computers together, and the chances that one may have some problem "talking" to the other is likely. The safest and fastest way to download image files is to take the memory card out of the camera, put it into a card reader, and in turn connect that to your computer.

Most shooters also agree that while on location, the only thing you should do with your images is loosely edit, rename, maybe caption, and back them up. Image manipulation, RAW processing into TIFF or JPEG, resizing, or any other advanced workflow step is usually done at home on your desktop system. Chances are a desktop monitor is bigger and better for fine work than a laptop monitor.

Navigate

Central to the entire operation is a good browser. Most photo software comes with some kind of browser that displays your images. Some browsers are easier and more user friendly than others, and often, the browser that comes with your image manipulation software may not be the best for you. Play with them a bit to determine your comfort level with a certain software.

Using more than one browser program means taking advantage of the strengths of each. Some browser capabilities are best for fast downloading, while others are best for organizing and editing.

The browsers that have garnered loyal followings among professional photographers are Adobe Bridge (www.adobe.com), Photo Mechanic (www.camerabits.com), Microsoft Expression Media (www.microsoft.com), and Cumulus Portfolio (www.canto.com).

I personally prefer Photo Mechanic for browsing. Designed by photojournalists primarily for news photographers—who often have to start transmitting their images before their CF card finishes downloading—it is a very clean interface, and the contact sheet of images appears almost instantly. Photo Mechanic automatically disconnects from your card when it's finished, preventing that dreaded "error" message when you inadvertently pull a card out of the reader without going through the unmounting procedure (which entails dragging the icon to the trash for Mac users, and a two step "safely unmount disk" procedure for PC users). I also use Adobe Bridge to access Camera RAW and Photoshop for processing my RAW files into TIFFs or JPEGs.

Integrated, browser/raw processor/database type programs like Adobe Lightroom and Apple's Aperture are examples of the all-in-one software packages designed to simplify the workflow of photographers by putting a lot of the tools they need into one application.

My Workflow

I usually create a folder for the day's shoot on my desktop. Because most of my work is travel oriented, mine will usually just say something like "PeruOne" for the first day's downloads, "PeruTwo" for the second, etc. Other shooters use dates, but frankly, seeing all those numbers simply confuses me. After downloading all the cards shot on that day, I go through them quickly for a very loose edit. This isn't a final selection—just tossing out the really, really bad shots. Even if it is a little questionable, it stays in on this edit.

Photo Mechanic, shown above and below, is very user friendly and an excellent browsing program. You can make edits quickly and easily by checking the box in the lower right corner of each thumbnail, rating the images, saving them in groups, or deleting them directly.

On the Road: Set the Correct Time on Your Camera

Setting the correct time and date on your camera is very important for a variety of reasons, but it becomes critical when shooting with more than one camera. If you are shooting an event with a wide-angle lens on one body and a telephoto on the other, in order for the pictures of each event to appear together when the cards from the camera are downloaded, the camera's time and date have to be synchronized to one another. Browsers can organize photos by capture time, so if your cameras are synchronized, all the images from both cameras will appear in the order in which they were shot. This makes editing easier and faster, because you're not required to search for all of the pictures from one event shot on different cards in different cameras.

In general, it is best to delete images from a browser program, rather than on the camera. Browsers like Photo Mechanic make this process extremely fast and easy. Simply choose the images you want to delete and tell Photo Mechanic to delete them!

On the Road:
Don't Delete In-Camera—Reformat

Unless you are really desperate for card space—as you might be if you were on your last card and in the middle of a fantastic photo opportunity—never delete pictures from the card while it is in your camera. Why?

The more in-camera deletions you do, the higher the possibility of corrupting the card or some of the files on the memory card. The safest way to deal with your cards is to erase them only by reformatting them in the camera. By reformatting a card each time you want to clear it, you are literally starting with a clean slate, with no orphan or corrupt files lurking about that can be created by deleting and erasing while the card is in the camera.

You'll have far fewer problems with missing or corrupted files if you make reformatting your card in the camera a habit.

The next step for me is to rename the remaining shots. Again, since I'm travel oriented, I name my pictures by their location. So I'll start with Bali 0001 and go up from there. If, by chance, it's my second trip to Bali, I'll use the name Bali 2001, or if my third, Bali 3001. You may want to use the date as the name (a system that many shooters use, but I find a confusing gaggle of numbers). How you choose to rename is up to you, but do rename to something more recognizable than the name and numbers assigned by your camera. You can go cross-eyed looking at all those files called "DSC0234" or "CRW 01234." The important thing is to pick a naming format and stick to it so you know your own system.

Renaming your images is very important. My naming system identifies where I took the pictures and when. In these examples, I'm using Photo Mechanic to rename batches of images. With the browser, I select the images I want to rename. When I direct the browser to rename the image group, it will give me a dialog with various options. In this case, Photo Mechanic allows me to apply a name and number to each image: the name identifies the group and the number gives each image a separate identity. Start the number series wherever you prefer; I usually start with "001" to keep it simple.

The next step in my workflow may or may not be important to your photography. Since I'm shooting for editorial and stock purposes, a good, informative, and accurate caption is essential for the picture to be of use to my clients. Photo Mechanic and most other browsers can embed all of this information, plus your name in the copyright section, in the IPTC portion of the file. Keywords are also important if you're selling stock, but those I apply later at home when I've done my final edit.

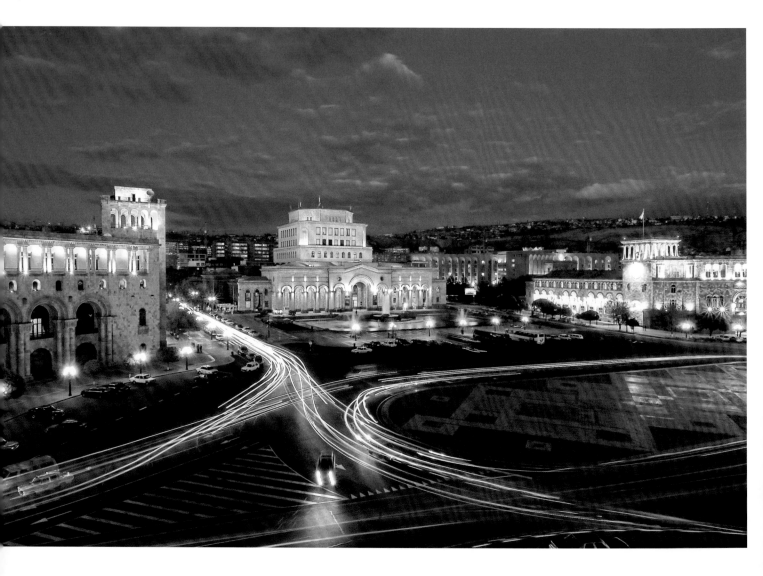

It is helpful to caption your images immediately after you download them for several reasons. The caption information about your shoot is fresh in your mind; it removes one more step that you might have to take later in the post-processing; and the browser allows you to apply general information—such as place, subject matter, and time—to a group of images all at once.

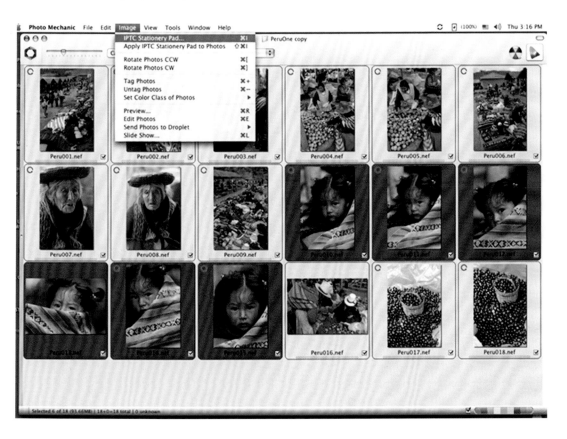

The stationary pad in Photo Mechanic is a great tool for journalists, documentarians, or practically anyone that wants to supplement the images with notes and information. Additionally, the browser attaches this information directly to the image file in the EXIF data, so that wherever the image goes afterward, the information stays with it.

Photo Mechanic has a "stationery pad" that allows you to enter all the pertinent information—the classic journalist's "who, where, why, when, and how"—and apply that pad to similar images, so captioning is fairly fast and easy. Much of my work is overseas, and many of the place names are in a foreign language, so applying my captions daily and on-site allows me to be much more accurate.

Yes, you can wait until you get home to do your captions, but chances are you'll forget or lose your notes as to what was going on in the picture. So as tedious as captioning on-site can be, I try to be diligent in this regard because my captions are much more accurate when the event is fresh in my mind.

Backup

Now I've got my day's work in a folder, loosely edited, renamed, and captioned. By this time, I'm getting either hungry, sleepy, or both, but my work is not yet done. Now the all-important backup procedure begins. Professional or amateur, if your pictures mean anything to you it is a wise idea to make at least one backup of them. Your laptop hard drive is not immortal; all hard drives fail at one point or another—it's just a question of when.

Chances are you'd get plenty of warning if your drive were experiencing problems, but it could happen in an instant, and all your pictures can go down with the drive. Backups are essential. (Yes, you can often recover data from a crashed or dead drive, but the cost often rivals that of an entire new laptop, and it's not guaranteed, so backing up is prudent.)

There are a number of ways to do this. If you don't have very much data, burning a CD or two is a good idea. But with most camera sensors recording 6MP and up these days, the storage space on a CD is probably insufficient to support a robust day of shooting.

A built-in DVD burner is standard on many laptops, and at 4.7GB, a DVD can store a fair amount of data. The problem is that burning DVDs on a laptop is still (as of this writing) a slow, time consuming process, often taking a half hour or so per disk. If you've had a busy day and you've got more than 4.7GBs of files, you could be up half the night burning multiple DVDs.

A far more elegant—and faster—solution is to buy a small auxiliary hard drive, one that connects to your USB (or FireWire for Macs) port and is bus-powered (that is to say, it draws the power it needs to operate from the computer itself, and requires no separate power adapter). Once you've done your daily workflow, simply take the folder and duplicate it onto the auxiliary hard drive. It takes seconds or a few minutes instead of hours, the drives are tiny and lightweight, and can hold up to 100GB or more.

I actually travel with two auxiliary 80GB FireLite hard drives, and I make three backups of everything. It's fast and easy and I can always take one of the drives and put it in the hotel safe or take it with me wherever I go, for safekeeping. Yes, these devices are

hard drives too, and chances are they will fail at one point too. But the odds of your laptop and your auxiliary drives failing at the same time are pretty slim. Those odds get even slimmer if you make more than one backup.

If all this sounds like I'm being overly cautious, or even "paranoid," it's a label that I accept gladly. Remember the wise words of Henry Kissinger, who once observed "even paranoids have some real enemies." When your livelihood depends on your coming back with photographs, and not excuses, there's no such thing as being too careful!

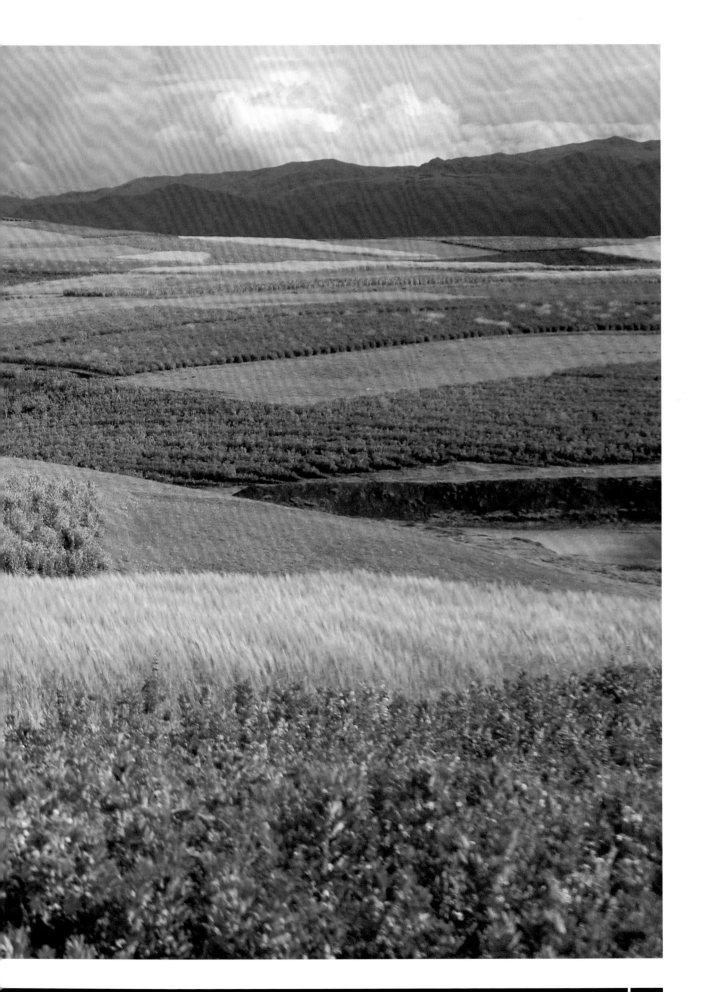

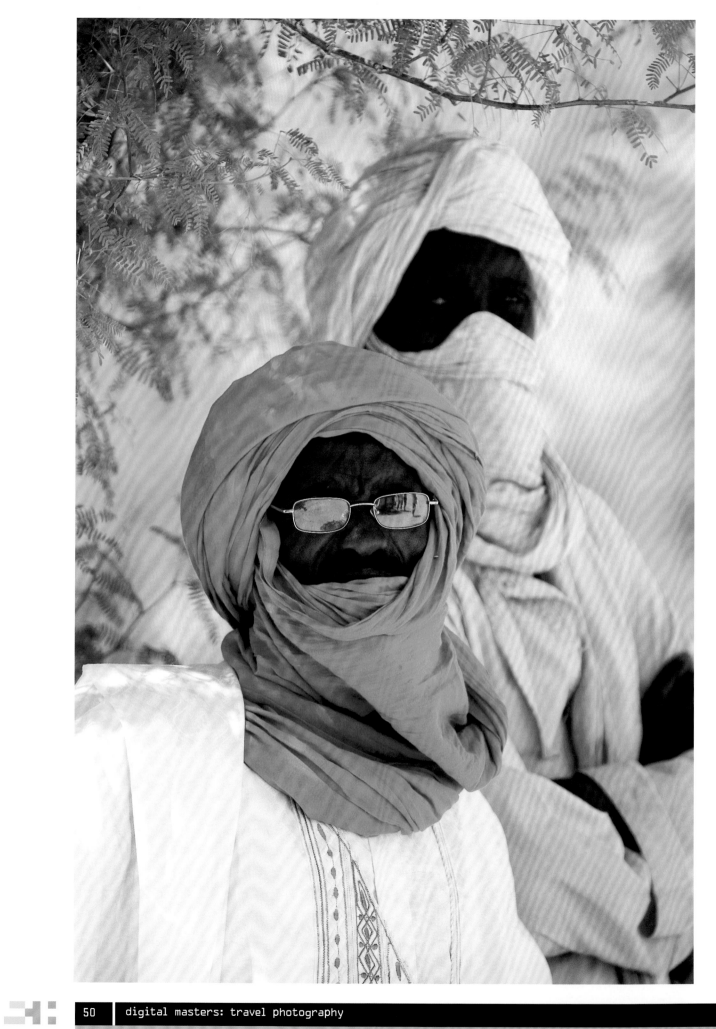

The Building Blocks of Good Pictures

Once you've gotten a hold on some of the logistical challenges of digital photography (notice I said "a hold on" and not "completely overcome"—it's a constant process), you've still got to make the actual pictures—hopefully beautiful and compelling pictures at that. Of course, it's one thing to talk about getting those kinds of pictures, it's another thing to actually be able to make them!

The first step is to try to identify just what makes a good picture. It's a subject that could fill an entire book by itself, but for me, it's a fairly simple formula. A good picture has to have three elements: good light, strong composition, and a sense of "moment." It's easy to group those three elements in a sentence, but capturing them in a viewfinder is an entirely different—and more difficult—challenge.

Once you identify these "building blocks" of a good picture, it is easier to look for them in the field and critique your work in the editing process. Don't get me wrong—I don't automatically throw out a picture if it doesn't have all three elements. (As the rocker Meatloaf once observed "Two out of three ain't bad," and I have to agree.) But the true portfolio pieces, the greatest hits, almost always exhibit all three elements. Let's look at these three elements, try to understand how incorporate them into our photos, and raise the bar on our photo quality.

Light

Light is the most fundamental element of photographs. The literal translation of photography means "writing with light" or "drawing with light." Beautiful light can make even the simplest subject matter into a thing of beauty, and good light can transform the mundane into the magical. On the other hand, you can have one of the most magnificent landscapes on the face of the earth in our viewfinder, but if the light is bad it's still going to make an ordinary picture.

Although there's only one source of natural light—the sun—it comes with a myriad of qualities and directions. The skill comes in matching the right subject matter to the appropriate type of light. Once you've got an idea of how to do this, you'll notice an immediate leap forward in the quality of your work. Let's take a moment and look at the different qualities of natural light and what subjects look good in them, both in terms of landscape and people.

Sidelight

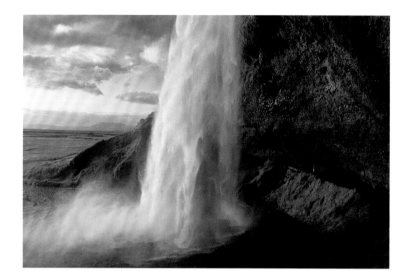

When sunlight comes low and from the side, it creates long, wonderful shadow placement that helps to give a three-dimensional feel to our photographs. Keep in mind that your sensor, your print, and your computer screen are all flat, two-dimensional surfaces. But the world we photograph is most definitely 3D (and maybe 12 or 14D if the quantum physicists are to be believed!). The only way we have to represent that three dimensionality is with the interplay of light and shadow. Italian Renaissance painters called this interplay "chiaroscuro," and you only have to look at the work of any of those artists—such as Leonardo Da Vinci—to see how this works, both for landscape and portraiture.

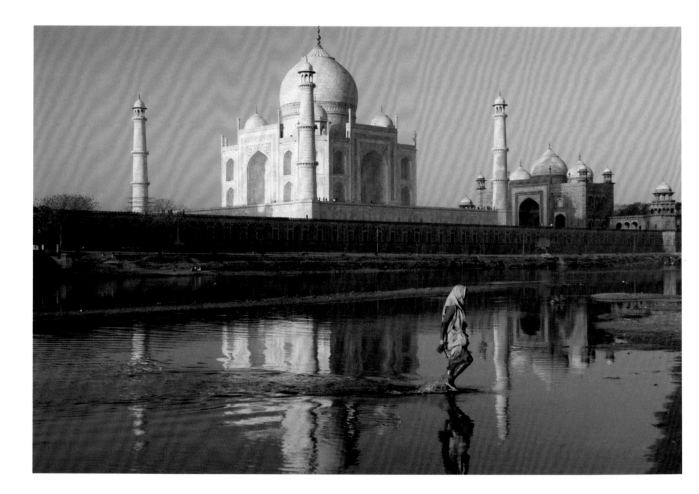

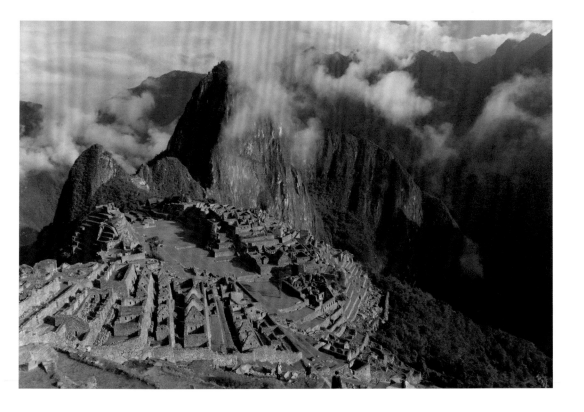

Low sunlight, which you might encounter early in the morning or late in the afternoon, has a nice, warm color to it. This is when the long red/orange rays of the light spectrum are evident; they will appear first thing in the morning with the sunrise and then again when the sun is setting, hanging around through the end of the sunset. In addition to the great sculpting quality of the light, it has a beautiful color cast as well.

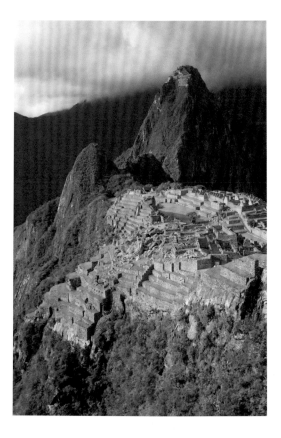

What about the light at high noon—doesn't it also cast shadows? Yes, for sure. But those shadows are usually in the wrong place because the sun is coming from straight overhead; this makes shadows too short and placed directly under a subject—very unflattering for people and landscapes. Because of the intensity of the sun at that time of day, shadows are often too impenetrable to be of much use for photography; the camera's sensor cannot capture both the bright highlights and the detail in the shadow areas.

Backlight

Magic happens when the light is coming from behind the subject, be it in a landscape or a portrait. Things take on a dreamy, nostalgic, almost romantic feel. True, color is somewhat suppressed, contrast is lowered, and flare (the reflection of a light source bouncing around in the elements of your lens) can be a problem, but the benefits of backlight far outweigh the difficulties of shooting it. With some careful technique, you can usually clear the technical hurdles without too much hassle.

Metering is a challenge with backlight, as the stray light entering your lens may not only cause flare, but also underexposure. Try to meter a portion of the scene that is not in direct sunlight and is as close to a midtone as you can find. Of course, your histogram (see page 30) is your best guide to exposure.

Sunrises and sunsets create lovely examples of backlight in landscapes. In terms of portraiture or people photography, a lot of glamour and fashion work is shot with backlight, as is most advertising and lifestyle photography, where the advertising agency is interested in promoting a feeling of well being. (Take a look around—almost any people photos you see in ads promoting financial planning, pharmaceuticals, consumer products, and so on are shot with backlight. It seems to trigger the type of emotions that advertisers want us to feel when we think of their products.)

Overcast/Open Shade

Unlike the human eye, which in a high-contrast situation can see a range of about 12 – 14 f/stops between a bright highlight and a deep shadow a digital sensor can see the equivalent of about 5 stops. Not much, you might say, and you're right, but slide film has about the same range, and color negative film—the best of all in terms of tonal range— has 7 or 8. So our recording mediums as photographers have never had the same ability to capture the extremes of light and dark; in other words, what we see with our eyes is not necessarily what we get in our photos.

The exception, of course, comes when you are already working in lower-contrast light that has about the same range of tones from bright to dark as our sensors can record. This light is prevalent in the nice soft overcast or open shade lighting conditions where the full, rich detail and great, saturated colors are easily rendered by the camera.

Admittedly, it seems a bit counterintuitive to actually prefer low contrast cloudy days instead of bright sunny ones, and for most landscapes, dramatic sidelight with well-placed shadows is certainly a desirable type

of light. But for many other subjects, including macro and close-up photography, street scenes, portraits, and even certain types of landscape shots (those primarily without the sky in the composition), slight overcast or open shade is the light quality of choice.

Twilight

Another low-contrast light much beloved by photographers is twilight. In fact, probably most of the "night" photography you see printed or published is not shot at night at all, but during twilight, that half an hour or so right after sunset and just before sunrise when the sky is a royal blue and not jet black. There's still a fair amount of ambient light around during twilight, and it helps to outline the edge of buildings against the sky and open up shadows in dark areas enough to be recorded by your sensor.

Twilight is the perfect time to shoot skylines, lighted monuments, and street scenes—any situation that mixes artificial lights (like street and flood lights) with the ambient light of early evening. Even certain unlit land-scapes can look good in twilight, especially those shot around water or in lighting condi-tions that have a lot of color afterglow bouncing off clouds before the sun rises or just before it sets.

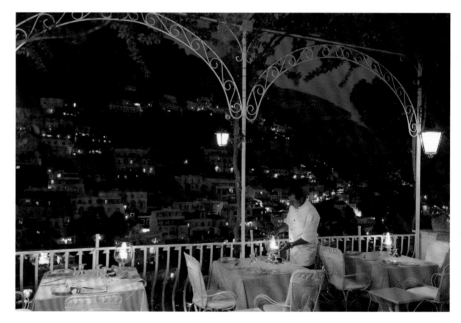

Photographers especially prize twilight because it is basically weatherproof. Whether the sky is perfectly clear or completely overcast, it will go royal blue at twilight. That means you're able to get dramatic shots with rich blue skies at twilight even if it's raining!

Depending on your latitude and the time of year, the actual length of twilight can vary dramatically. Near the equator and in the tropics, for instance, twilight is usually a very quick affair, maybe lasting 15 minutes. In the extreme latitudes in winter, twilight might be as bright as it gets all day, and may last for hours. In the moderate latitudes, you can usually count on about a half an hour.

There are several excellent websites and software programs that chart the twilight times for specific locales, along with sunrise, sunset, and even phases of the moon. If you have Internet access, www.sunrisesunset.com will give you this information, provided you know the GPS location or the proximity of the location to one of the hundreds of locations they have in their database. Another superb program for charting this information is Hourworld (www.hourworld.com). This

information stays on your computer, so if you can't get to the Internet, you can still access the info (again, provided you know your location). The program stores up to seven years of information, so my current version has data out to 2014, when I'm sure there'll be an update available!

Using Filters in the Digital World

Since migrating to digital, my equipment closet has many tools I previously used daily that are gathering dust—there's that very expensive and beloved Polaroid back, my venerable Pentax 645 outfit, and a slew of filters. Most of the latter are color correction and light balancing filters; now I do all of my color correction and light balancing with a slider in my RAW processor.

But unlike some of my colleagues, I still carry a fair number of filters, because there are things I'd rather do at the moment of capture than back in my office or hotel room.

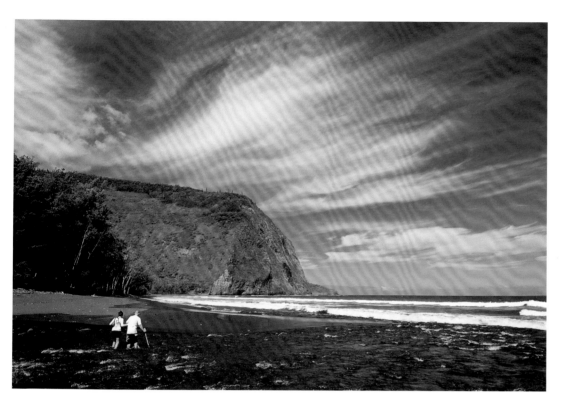

The special properties of a polarizer—its ability to cut through haze and eliminate reflections from nonmetallic surfaces—are hard to emulate in the digital darkroom. You might hear about "linear" and "circular" polarizers—this can be the source of some confusion. Despite their names, those terms don't describe the shape of the actual filter, just the way the sandwiched pieces of glass achieve polarization. The metering and autofocus sensors in our digital cameras almost always require the use of a "circular" polarizer to work correctly (check your camera's manual to see which type it requires).

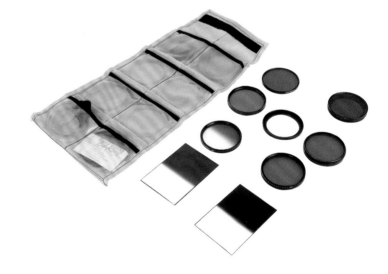

Some polarizers are offered in combination with other qualities, such as a warming filter/polarizer combination. This was a favorite of mine in my film days; I found that the polarizer and added warmth looked great on film. Shooting digitally, I no longer bother with the warming polarizer, because I can easily add or subtract warmth in the digital darkroom.

There are other polarizer combos that I still carry. The Singh-Ray ColorCombo LB Polarizer combines a touch of warmth, intensifying colors, and polarization—all in one filter that is about 2/3rds of a stop faster than a regular polarizer. All these effects could probably be emulated in post-production Photoshop work, but my whole philosophy in digital photography is to spend

as little time as possible in post production and as much time as possible outdoors shooting pictures. This warming polarizer is one tool that helps me do that.

In my film days, I was a big fan of another unique Singh-Ray creation: the Gold-n-Blue polarizer, an amazing piece of glass that, when used correctly, could make midday light look like a golden afternoon, a dingy dusk look rich and blue, or a lackluster sunset glow with warmth. It was like Photoshop in a 77mm retaining ring! Like Photoshop, however, the results you got depended very much on your skill and experience, because the Gold-n-Blue polarizer could also produce garish and completely unnatural looking results.

When I first used it on a digital camera, though, my results were not the same—it resulted in muddy pictures with a magenta cast. It took a little while to work out how to use it, but I finally worked out a method in my Adobe Camera RAW converter that gave me the beautiful results I remember from using this filter with film. Essentially, it involves lowering the Kelvin temperature to about 3200K and adjusting the Tint control to anywhere from -30 to -50 (which takes away the magenta caste) and voila—out come the rich blues and beautiful warm tones this filter was famous for in the film world. Yes, it involves some dreaded (by me!) extra steps in post processing, but the results are worth it.

The other type of filter I still carry is the neutral density (ND) filter. NDs block light from entering the lens in two ways: evenly across the field of view of the lens, or selectively blending from gray to clear, as in the graduated neutral density (grad ND) filters. Since I'm a travel photographer and am constantly looking to do more with less, my ND filter of choice is the Singh-Ray Vari-ND. This rotating filter allows you to dial in the desired strength of the neutral density, with a range of 2 to 8 f/stops! No more carrying a series of NDs in varying strengths—you've got them all-in-one with this filter.

I also confess to still carrying my set of three grad ND filters (in 1, 2, and 3 stop configurations). These are the rectangular shaped filters that go from gray to clear, and are designed to lessen the contrast range between the bright skies and darker foregrounds found in many landscape situations. Remember, the digital sensor cannot record wide ranges of contrast, so in order to have detail in both sky and foreground, I use these filters to "hold back" the exposure in the sky.

I can already hear the thoughts of the avid Photoshopper who may be reading this: why not do this in post? Before you dash off any letters or e-mails to me about Photoshop's great "Merge to HDR" action, where you can combine several exposures of the same scene into one image with an incredible range of tones, let me say that I know all about "Merge to HDR," and it's fantastic—as long as you are on a tripod!

It requires images that are precisely the same, but shot at different exposures. I also know about processing the same RAW file once for highlights, once for shadows, and then combining the two files into one. It's a great technique too—one that would allow me to spend even more time in front of my computer than I do now. Oh boy!

Because I shoot a lot of street photography and moving subjects, much of my work is handheld and I can't use "Merge to HDR"; in fact, I'd rather be doing just about anything—shooting, eating, sleeping, or even exercising—than merging two interpretations of the same RAW file in post production. It's just not my cup of tea.

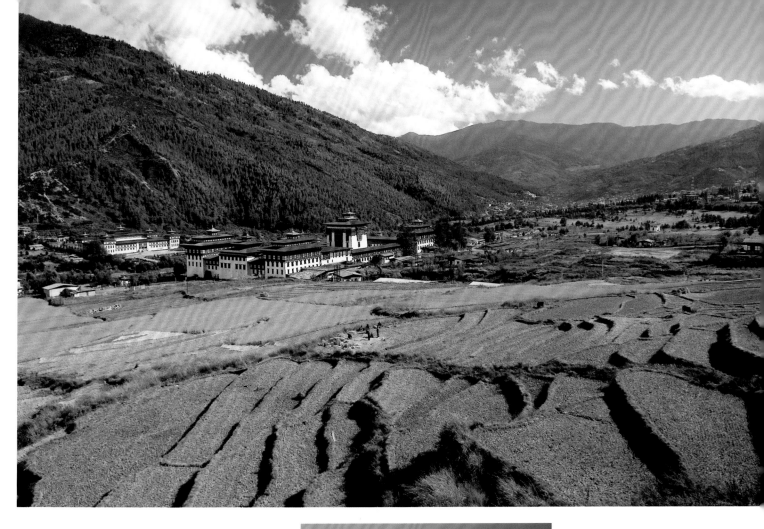

So what do I do when faced with a high contrast scene? Simple. Put on a 2 stop grad ND and shoot away! Old slide-shooting habits die hard, and the grad ND was a staple of chrome shooters. I still find myself in handheld situations where a grad ND is incredibly helpful and saves me from burned out skies and impenetrable foregrounds.

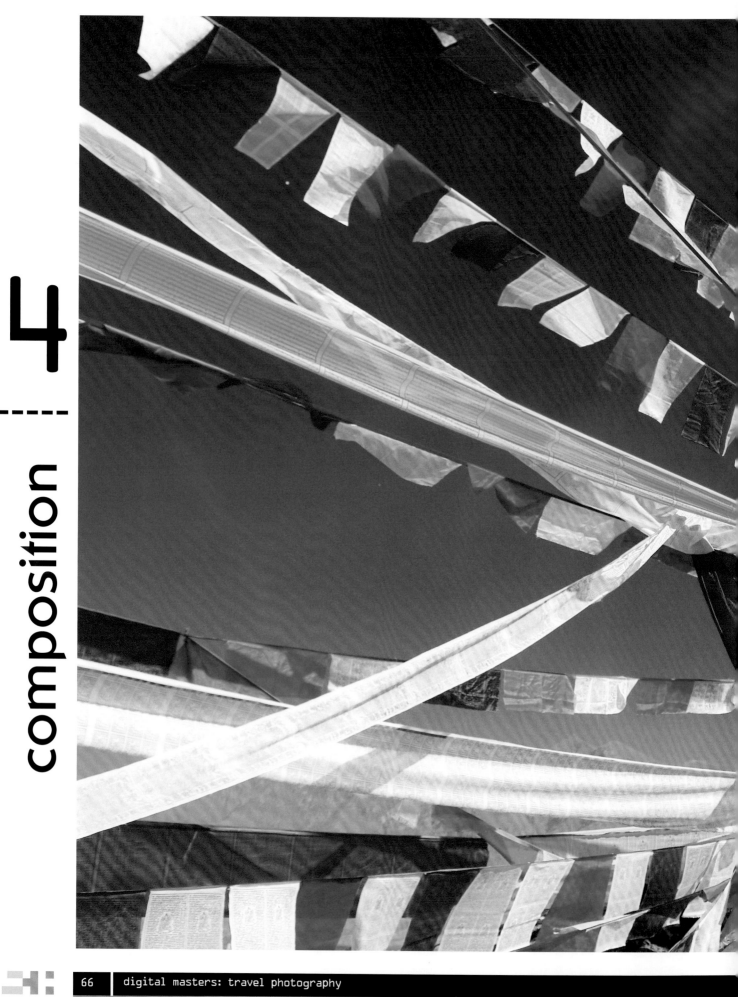

4

composition

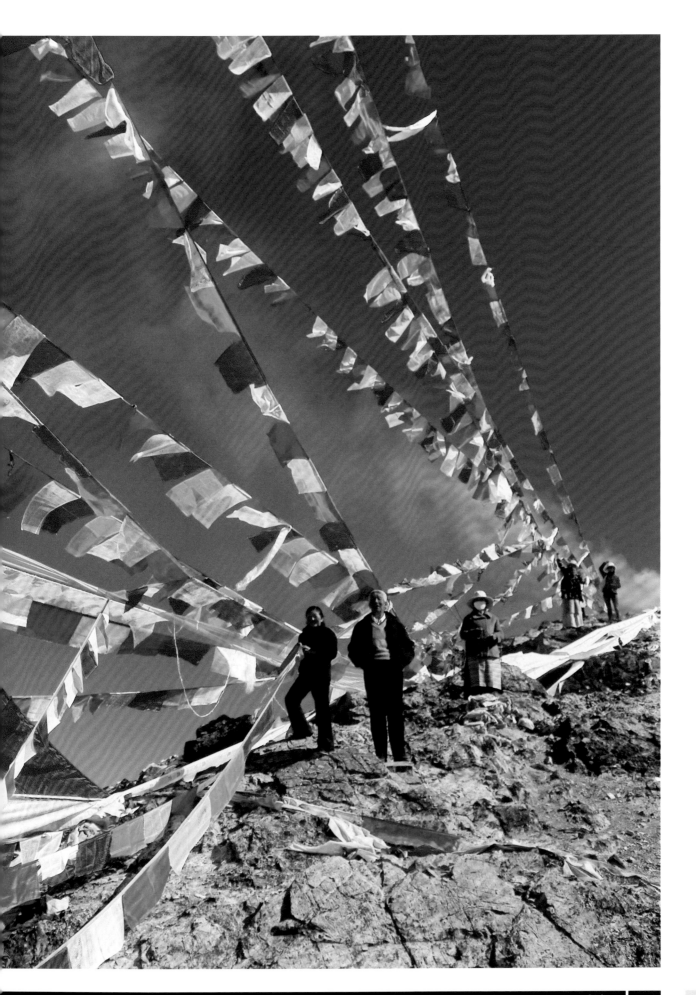

Composition

Composition—no less an important building block of a strong picture than light— is how you organize the elements in your photograph in a pleasing and dynamic way. There are some classic guidelines that can help to achieve this, but as with any art form, sometimes you have to throw out the rulebook or the guidelines to make something original.

However, before you can ignore the guidelines, you must have a familiarity—if not a mastery—of the concepts. A quick perusal of the myriad of photo sharing sites on the Internet reveals there are many folks out there using their cameras without an iota of compositional sense. Many of these unskilled shooters take refuge behind the shield of "personal vision" to defend pedestrian, or just downright boring, photography.

I'm just as interested in seeing fresh and original work as anyone, but I draw the line at sloppy composition, weird framing, and slipshod attention to light quality as being good simply because it may be different. Let's take a look at a couple of compositional guidelines; you can always chuck them aside later if they're cramping your creativity!

One Center of Interest and a Clean Background

More pictures are ruined by clutter and busyness than any other compositional flaw. As a photographer, you may fall in love with one element in an otherwise busy frame and all your eye notices is that element. However, your camera sees everything and so will the viewer of the photograph. The quickest way to improve your photography—and your compositional eye—is to simply decide what is attracting your eye to the shot and fill the frame with it!

Sounds simple, right? So simple that many people simply forget about it, preferring instead to jam a lot of elements into the frame in a willy-nilly fashion, usually against a busy and competing background. An easy way to overcome this tendency to shoot loose and sloppy is to get continually tighter when you are framing a picture until you feel there might be something missing—that's usually when the primary subject begins to dominate the frame.

Jay Maisel—one of the great color photographers of our time—advises shooters to let their eye roam around the edges of the viewfinder to check for unwanted clutter and peripheral elements before pushing the shutter button. Granted, there are some situations where this delay would result in missing a shot, but practice it as often as you get the chance.

More often than not, however, you've got time to give your frame a once over. You might be surprised how often you concentrate only on what's in the middle of your frame and ignore the periphery. I call this phenomenon bulls-eye vision. Fortunately, you can cure this without a visit to the optometrist; just follow Maisel's sage advice.

Once you've isolated the key point of interest in your frame, move it out of the center. The so-called "rule of thirds" is another classic bit of advice that everyone knows—but not many remember—when it comes to framing a photograph! If you divide your rectangular frame in thirds horizontally and again vertically, the four places where those lines intersect (all around the center, but not in the center) are very strong places for your center of interest.

Leading Lines

Leading lines are linear picture elements that lead your eye into the composition. A leading line can be a fence, footprints in the sand, or a row of buildings. They are everywhere, if you train yourself to look for them. They are often at their most effective if they cross the frame diagonally and are naturally suited to vertical framing, although they work just as well with horizontals.

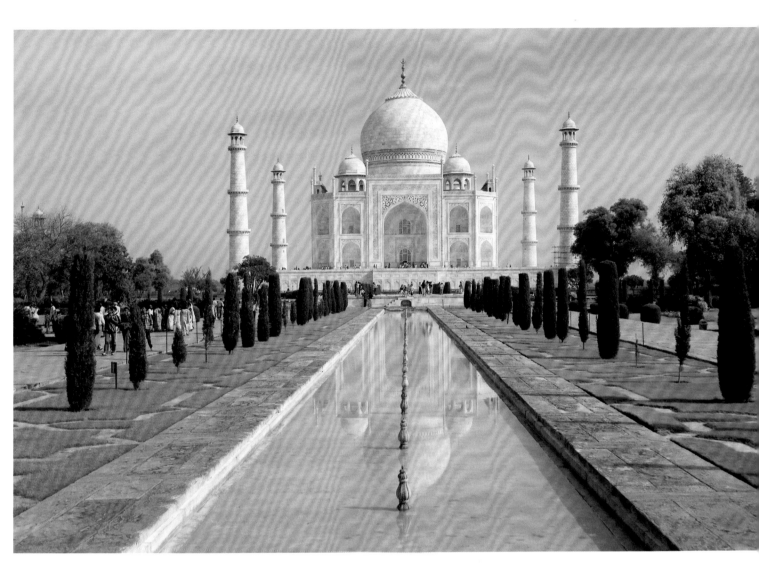

Leading lines are not necessarily straight. In fact, the classic "S" curve is one of the most pleasing leading lines and it occurs more often than you'd think in natural and man-made scenes. Envision the course of a river, wind-carved ridges in a sand dune, or a country road meandering across a hillside, and you will see the "S" curve.

A raised vantage point is a good way to see the leading lines in a scene. Things that look chaotic from eye level often take on a nice symmetry when seen from above. I always scan my surroundings for hillsides, observation towers, building roofs, open air restaurants, and cafes that are above street level— anywhere that might offer a nice perch.

Foreground Frames

Foreground frames are naturally occurring frames through which you can shoot your pictures. They're almost always done with wide-angle lenses (thanks to that lens optic's great emphasis on the foreground) and they are everywhere. Whether it's a tree branch, a porch railing, an archway, a bicycle wheel, or a hanging fishing net, you can often find something to place in the foreground that will help give a sense of depth and three-dimensional quality to your photographs.

Usually, but not always, you'll want the framing element to be as sharp as the scene it surrounds, and that usually means using a smaller aperture and maybe even a tripod. With long lenses, though, a nice out-of-focus foreground element, like hanging flowers or even just a bough of green foliage, is not such a concern.

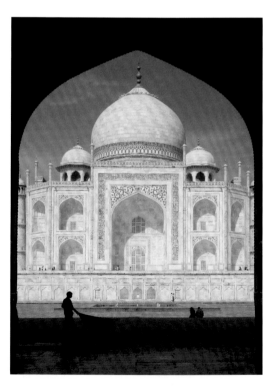

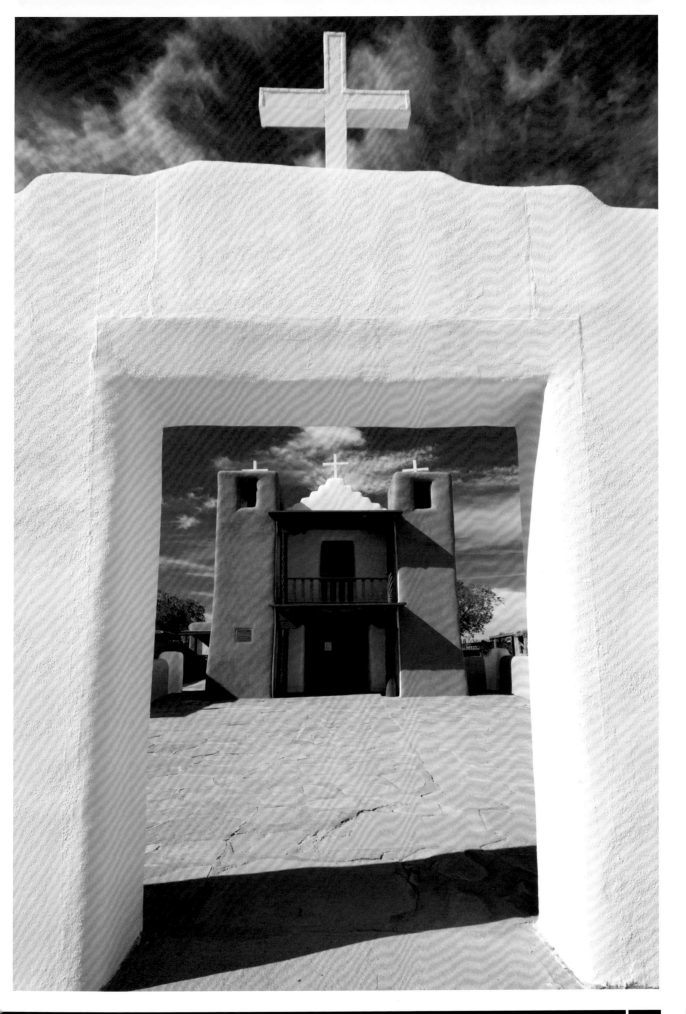

digital masters: travel photography

Foreground Interest

When using a wide-angle lens, it's not so important what you place in the foreground, as it is to actually do something with the foreground. Foreground frames and leading lines are good, as are patterns of leaves, sand dunes, statues, and even people. It is important to remember that, because the foreground is emphasized (especially using a wide-angle lens), the worst thing you can do is waste all that "real estate" and leave the area empty (unless, of course, that's the point you're trying to make with the picture).

A strong foreground element can also create a storytelling scenario in one frame by relating the foreground element to something in the background. This is a classic news photographer's tool, and you'll see it done to perfection in pictures of news events—a victim of a natural disaster in the foreground, holding what they've salvaged from their house, with the ruins of the house in the background, for instance, is a universal formula for news photos.

It can also be applied to less tragic circumstances: a dramatic, hand carved Gorgon head in a Roman temple with the ruins in the background; a flower-strewn hat of a Polynesian woman with a ceremony in the background; or even a bi-plane pilot in the cockpit with another plane trailing along. The scenarios are endless, and limited only by your own imagination. Using a wide-angle lens in this way is almost counterintuitive; you have to get very close—almost uncomfortably close—to the foreground object to make this work.

A strong foreground element is also necessary for those "layered look" photos done so well by the classic street photographers and the Magnum photojournalists. These are the exception to the "keep it simple with one center of interest" rule. These pictures have multiple centers of interest, dynamic juxtapositions, and complex narratives. It takes a trained eye, patience, and a lot of shooting to make this type of shot work, but when it does, it is very effective. Layered pictures take a lot of practice, and sometimes the difference between a busy, jumbled picture and a work of art is often so subtle it takes a well-trained eye to recognize it.

Scale Elements

When you're shooting wide-open spaces, you might need something of a familiar size in the frame in order for the viewer to appreciate the scope of the scene. In many cases, it's impossible to tell the height of a waterfall, for instance, without an object of recognizable size—like a human, a car, or an animal—with which to gauge it.

Not every landscape needs a scale element. A tree-lined dirt road winding through fall foliage in Vermont, for instance, is already loaded with scale elements; the road, the trees, and fences along the way are serving that purpose. But a rock sculpture—or the kind of otherworldly landscapes that are part of the American Southwest, for example—really benefit by including a scale element in the frame.

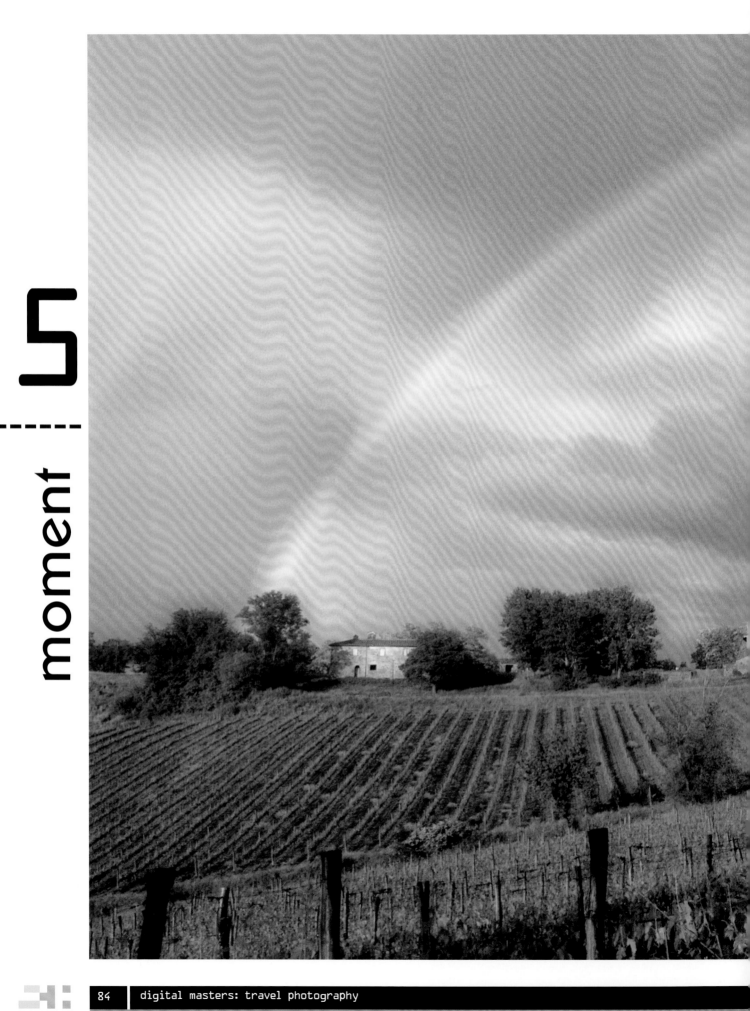

5

moment

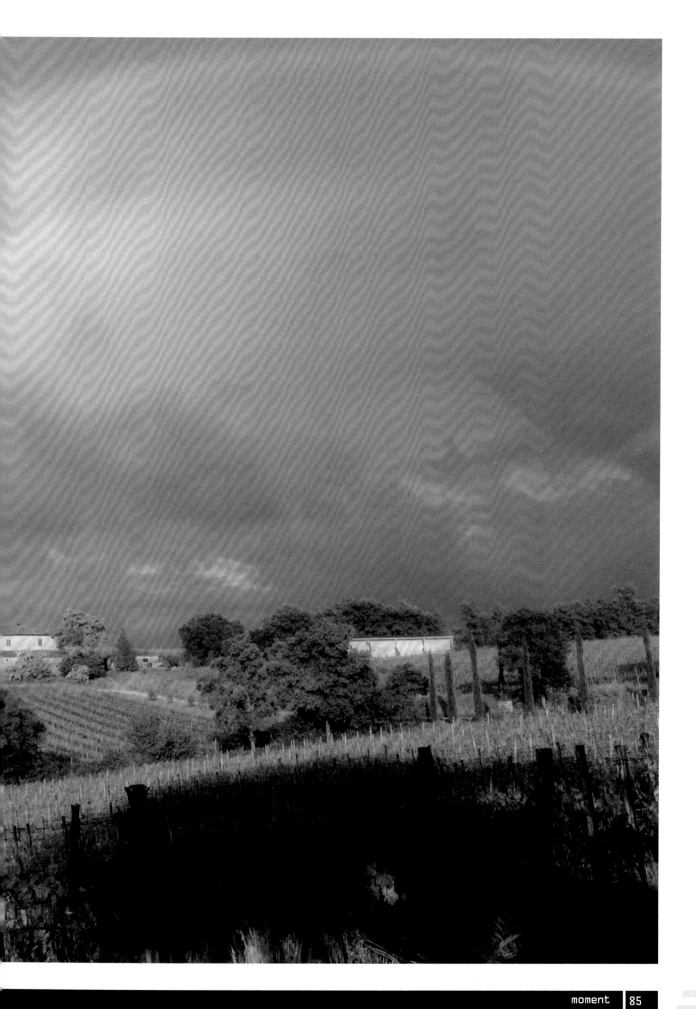

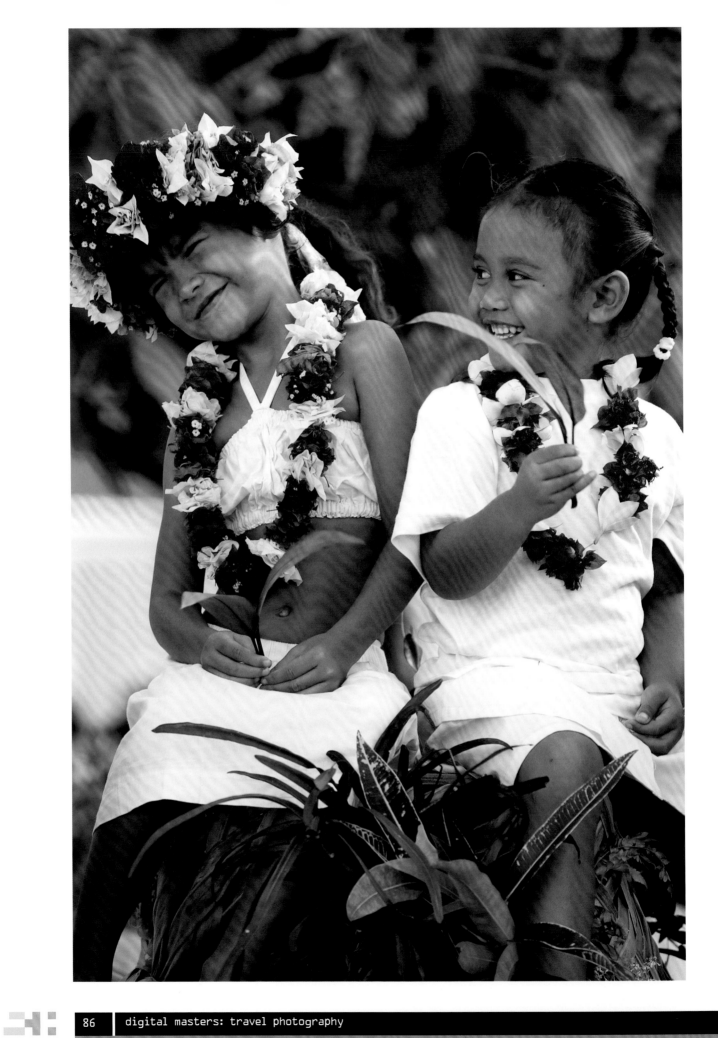

The third building block of a good picture, and probably the hardest to define and therefore the hardest to capture, is the sense of "moment." It is arguably the most important element in creating a memorable image. Many editors, and most viewers, will overlook technical shortcomings in a heartbeat if the photograph contains an overwhelmingly original, funny, or poignant sense of moment.

Why is the sense of moment so important? There is research that suggests the human mind may tend to remember scenes in terms of still images, rather than moving images. To test this, think of the Vietnam War. The images that come to mind are probably the young girl running down the road and covered in burns from napalm bombing, or Eddie Adams's Pulitzer Prize-winning image of the pistol toting South Vietnamese officer executing a Viet Cong colonel at point blank range. If it's World War II, it's raising the flag on Iwo Jima, and the sailor kissing the nurse in Times Square. The possible exception could be the Kennedy assassination, where the Zapruder film clip is indelibly etched into our collective psyches—but even that film clip is often seen as a series of excruciatingly detailed stills.

It is entirely possible that we are hard wired to retain still images, precious slices of time that carry epiphanies we can file away in an onboard hard drive (our brains) and retrieve as needed. The wise photographer, then, will go out of his or her way to try to capture those memorable moments. But how do you capture that kind of moment, you might ask? Ah, there's the rub.

There's a lot of philosophical advice out there about this subject, some of it Zen-like in its abstract simplicity. I started my professional life as a newspaper photographer in New Jersey, and at that time an old-timer gave me this advice: "There's nothing special to getting a great news photograph, it's just a matter of 'f/8 and be there.'"

Just "being there" when magic moments happen is easier said than done, but it certainly helps. A friend and colleague, *National Geographic* photographer Mike Yamashita, sums it up another way: "Photographers are paid to be lucky," Mike says. "We're just expected to be in the right place at the right time." Another friend and *Geographic* shooter, Jim Richardson, puts it this way: "If you want to become a better photographer," he advises, "just stand in front of more interesting stuff!"

A pithy saying is illuminating, but is there anything a little more concrete in the way of advice to help us capture moments? The good news is that yes, there are things you can do to tilt the tables in your favor—or more accurately just even up the odds a bit—when it comes to capturing moments. Some of these things are very simple; some require practice, patience, and a large helping of good luck.

Visual Homework

Jim Richardson has it right—as photographers, we want to stand in front of the most interesting stuff we can find. Many photo enthusiasts just assume that professional photographers are lucky, but in truth, a lot of great editorial and travel photography is the result of meticulous and exhaustive research to find that "interesting stuff."

The first thing I do when I'm planning a trip is to do some picture research on the Internet to see what the place looks like. In the pre-Internet days, this used to involve going through a lot of back issues of *National Geographic* and other travel magazines, photo-driven guidebooks, newspapers, and coffee table books. Indeed, I still do a little of that, but the easiest way to do some research is to go to one of the big stock photo websites, such as Corbis or Getty (www.corbis.com and www.gettyimages.com), and see what they've got. They are among the largest of the professional stock photo sites, and you'll get an impressive selection

On the Road:
Working with a Fixer

Professional travel photographers and photojournalists know all too well that, in order to get closer to the people and culture, you sometimes need a "fixer." A fixer is a guide/translator/photo assistant type of person who can help overcome the barriers of language, strange surroundings, and unfamiliar logistics.

A good fixer really helps you track down and make much more interesting, insightful photographs. But a private guide or fixer can be expensive, and that's why most travel, especially overseas, is done in groups with a tour guide. The cost of the guide is spread out among the group. Unfortunately, it's also in a group where the "cocooning" of tourism kicks in, but there are ways around this obstacle as well. Check with the tourist board of the country you're going to visit to see if they have a "people-to-people" program. These programs set you up with an English-speaking local who may even share your interest in photography. I've made several lifelong friends, whom I first met through these types of programs. They also took me to places and introduced me to people in their countries that I could never have found by myself.

Some US-based camera clubs and photographic associations have rosters of affiliated clubs in other countries with English-speaking members who volunteer to act as guides for visiting photographers. This is a great and very inexpensive way to tap into the local expertise. You can also check the travel photography bulletin boards on the Internet and post an inquiry, asking for recommendations of guides in the place you're going to visit.

Some of the best "fixers" I've ever worked with were university students. From France to Japan, I was able to track down English-speaking students who were enthusiastic, knowledgeable guides and worked for the price of lunch, bus fare, and the chance to practice their English and show off their country. I found these students by first talking to the tourist board and getting contact information for professors in the art, journalism, or photography departments of the local university. I explained my assignment and asked if there were any students who'd be interested in picking up some photographic knowledge and a few bucks accompanying a photographer.

Sometimes you can't track down a "fixer" in advance. No problem—you just have to keep your eyes open once you arrive. I usually start by visiting the local tourism office to ask about volunteer guides. But a particularly helpful bellhop or taxi driver, who is willing to work with you on his off hours, may do the trick as well. For photography, it's not so important that your guide know all the history of the destination, but that he understands what you're after and has a way with people.

On assignment on the island of Gozo in Malta for *National Geographic* magazine, I went through three "official" guides from the tourist office; they were walking encyclopedias of the country's history, but were so academic and intellectual that they were unable to connect me with the real people in the street.

Finally, in a coffee shop, I struck up a conversation with Tony, a retired policeman. He was so friendly, and everyone knew him. The first place he took me was the first communion dinner of a family he knew. It was a great photo op, and after that he took me to local bars and football clubs, where we were always welcomed with open arms. I was able to shoot these slices of real life that would have otherwise remained hidden.

of imagery. You can also expand to a Google image search, or go to other picture portals like Alamy or Flickr (www.alamy.com or www.flickr.com).

The point of this research is not to copy these pictures, but to get an advance look at the place you are going to see. What can you learn, and why is this valuable? If you see a lot of elevated views of say, the main square in Munich, you can be sure there is probably an accessible place to shoot from this high angle, and you'll know to start looking for it. You may even be able to glean—from the clocks on the towers or info in the caption— what time of day might be the right time to shoot the view.

There are two schools of thought on doing this kind of visual homework. One says that it is better to go without any preconceptions, so you can discover your own pictures. The other, the one I and many other pros subscribe to, says that you will always discover your own pictures, but it never hurts to know if there are some killer overlooks or angles that you may otherwise not discover (at least, not in the timeframe that most travel is done these days).

For instance, there's an overview of Salzburg, Austria called the Monchberg that you could easily miss without doing research, yet tons of shooters have gone up there before to shoot. Although it is a common shot of Salzburg, I go up there each and every time I visit, trying the view in a different season, time of day, and weather conditions. You never know when there just might be that magic combination of elements that will make your view from the Monchberg the unique or signature view.

Don't worry too much about freshness or originality; in most situations where you are shooting in a new location—be it in the next county or a different hemisphere—you're sure to be disoriented. Freshness is no problem since you are completely new to the situation. What you might need, though, are some visual touchstones that seem at least somewhat familiar so you can orient yourself and work in an organized manner.

Besides angles of view, research can provide you with interesting events to photograph. I never fail to get the "What's Happening" listings for whatever region I'm visiting. These are guides put out by the tourism boards of cities, countries, and regions that list festivals, special events, parades, or anything that might be of interest to a visitor, and they are a gold mine of information. If possible, I also scour the local papers for other upcoming events. If there are no English-language newspapers around, I might ask for help from a hotel concierge or front desk staff to keep me posted of any interesting events they may read about in the local paper, whether it's a first communion ceremony or an outdoor concert.

Once you track down an interesting event, don't forget to get there early and prowl around the edges of that event. Many of the most interesting moments you encounter happen at the peripheries—the Chinese opera troupe putting on their makeup in little trailers prior to the outdoor performance, little girls passing time on top of their parade float by tickling each other with a feather—those slice-of-life moments that often occur around big events.

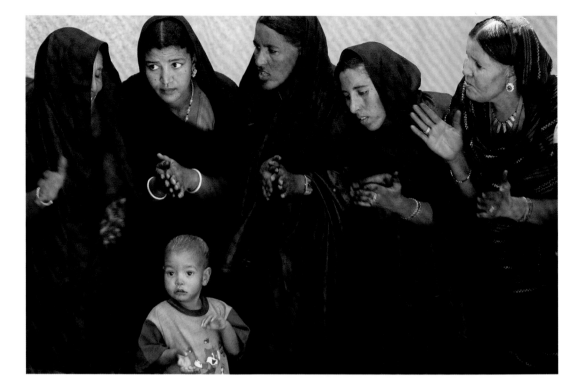

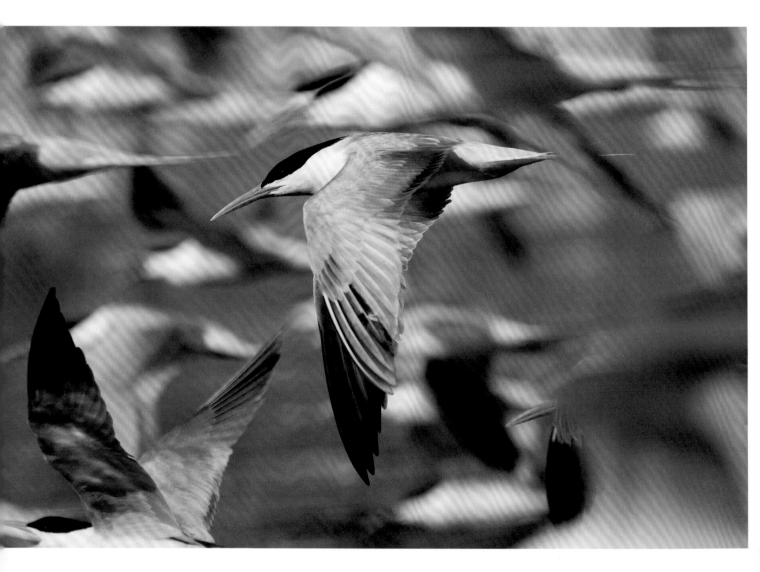

Anticipate Action

Much of the art of capturing a moment comes as you develop the ability to anticipate action before it happens, and be ready with the camera when it does. It is hard to describe this ability in cut-and-dried terms, because it's kind of a sixth sense you develop with practice; newspaper photographers and photojournalists refer sometimes to "reading the street" or "reading the situation." It's the rare photographer who has the reflexes and the command of his or her equipment to snag a fleeting instant once it actually occurs. To capture a moment, you have to be able to see it coming.

You can learn to recognize situations that may develop into moments by doing some serious people watching, in, say, a park on a pleasant afternoon. Spot the mother cooing to her baby in the carriage? At one point, she'll pick up the child for a hug and "snap," you've got your moment. See the dog chasing the Frisbee? Eventually, he's going to sail into the air for a dramatic catch, and if you've been following the action through your viewfinder, you'll get it. That young couple strolling hand in hand down the path? It's only a matter of time before one will lean over to plant a kiss on the other.

As Carly Simon sagely observed, "anticipation is making me crazy," and indeed, you'll often find yourself waiting for something that never happens. However, with a little practice, you'll get better at recognizing situations with "moment" potential.

A Backdrop for Moments

The ability to anticipate action is probably the single most important skill in capturing a privileged moment, and it can take many forms. Sometimes, it means recognizing a good background or potential picture setting, one that is worth waiting for or returning to when there is something happening. For instance, scenes like a painted mural on the side of a building in an urban playground, a row of trees bedecked with fall colors, or an appealing curve in a mountain trail may not make great pictures in and of themselves. However, wait for a game of pickup basketball to happen in front of the mural, or a pair of joggers to run down the line of trees, or a hiker to come around the bend in the trail, and suddenly the scene has the sense of moment it was lacking. There's no set rule on how long you should wait for the elusive moment—you have to use your judgment. Sometimes it's better to come back to the scene at different times in order to increase your chances.

Weather

Just as you recognize the potential for great moments in front of interesting backgrounds, you can also do the same for unusual weather. Nothing gives the sense of capturing a moment more than when you catch a scene in unusual weather—a full rainbow, a shaft of sunlight penetrating a cloudy sky, or a bolt of lightning streaking across the frame.

Don't put away the camera if the weather takes a turn for the worse; bad weather can make for some very interesting pictures. When I'm on assignment and it's really raining or snowing, I get out with my camera, because I know that these conditions can transform the mundane into the magical.

Once, on the island of Dominica, I noticed that the late afternoon showers produced a few rainbows here and there. The trouble was, I was never in the right place to capture them—there were always buildings or telephone lines in the way. After a couple of days, I finally hired a fishing boat to take me out into the water so I could move around and put the rainbow wherever I needed it in the composition. The captain thought I was crazy to be sitting idly in a boat without a fishing rod, but soon enough, the rainbows appeared, and I snagged my catch: a shot of a beautiful rainbow soaring over the mountainous coastline.

Action

There's no doubt that you can give your photos a great sense of moment when you photograph sports action, whether it's football, a bullfight, a rodeo, or even your kid's Little League game! When it comes to photographing action, one of the best ways to capture the moment is to freeze it with a high shutter speed of 1/500th of a second or higher. You need practice to capture the peak moment this way. The narrow depth of field of a long telephoto lens–200mm and longer–will help to soften distracting backgrounds and make your subject "pop." *Sports Illustrated* is filled with graphic, exciting photographs shot this way, and it is a great place to get some inspiration.

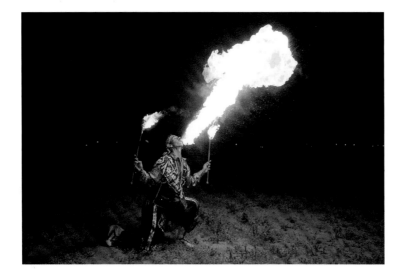

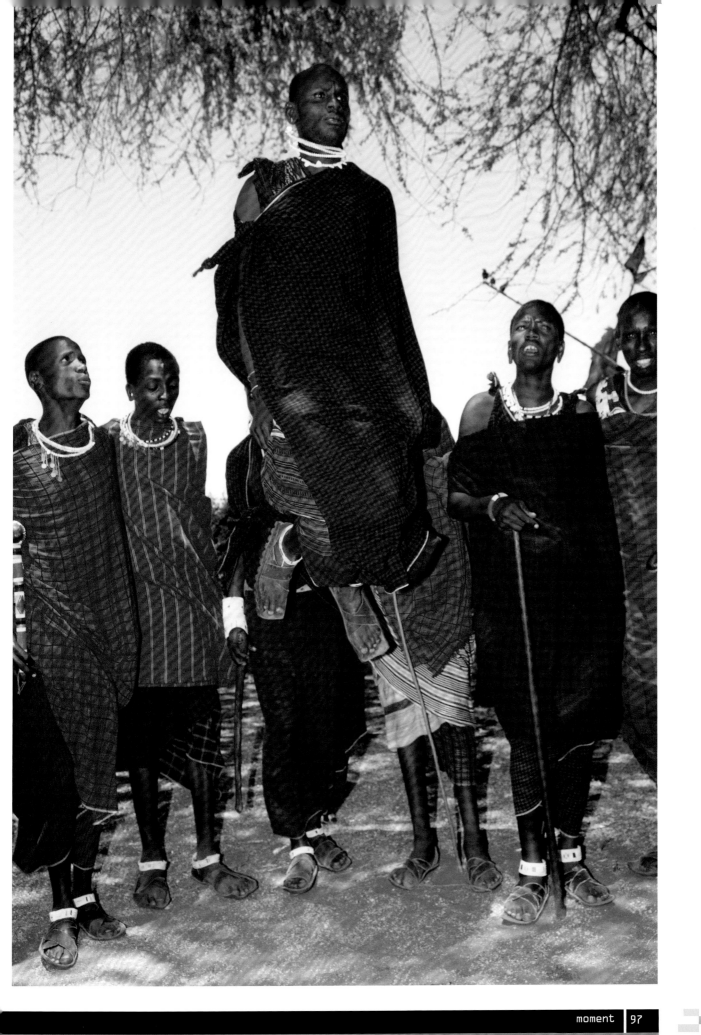

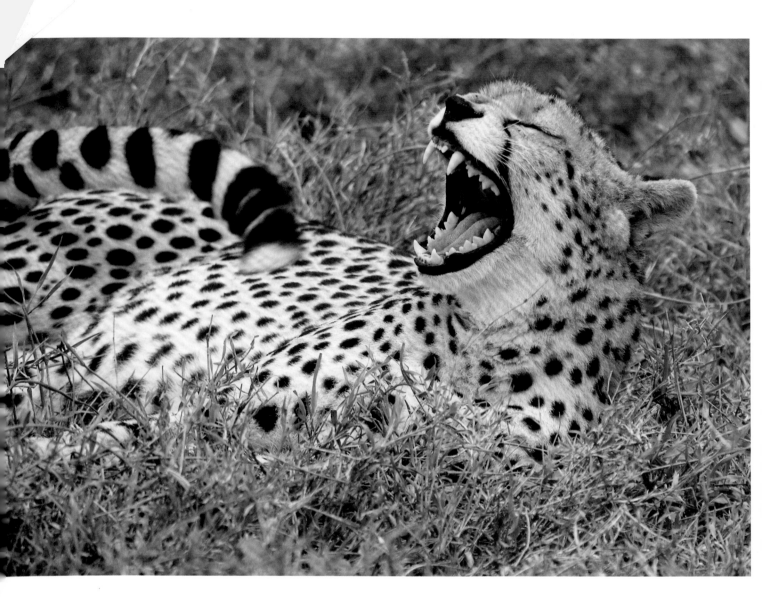

Sports aren't the only place to look for peak action. Nature is full of the same drama. Wildlife pictures definitely benefit from a sense of moment; when a cheetah pounces on its prey, for instance, or a herd of antelope all leap into action. Like a good sports photographer, you learn to anticipate these dramatic moments. Even wildlife portraiture benefits from good timing. Rather than just getting a good "head shot" of a lion, try to capture one in mid-roar (or even mid-yawn). These moments all give an added sense of life to a still picture.

Of course, you can always go to the other extreme when trying to give a sense of moment by blurring it, instead of freezing it. There are two situations where this technique works well. The first and more common situation is when the subject is moving, but the background is stationary. The second is when the main subject is stationary, but the background is moving.

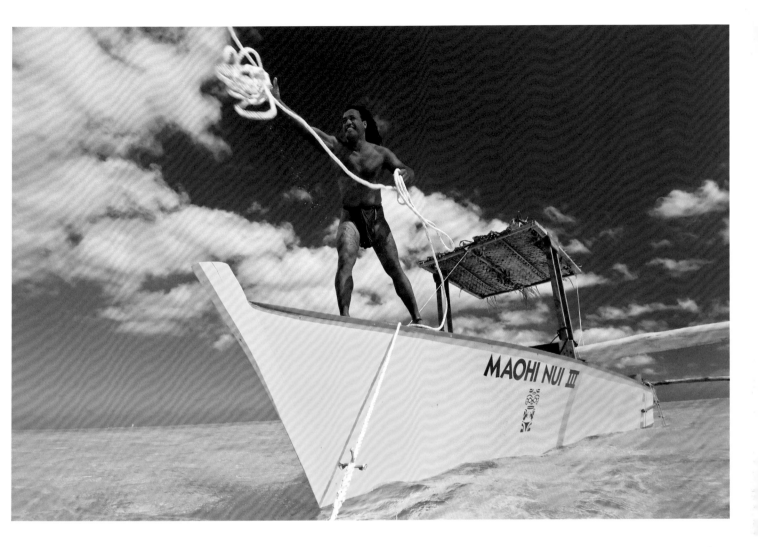

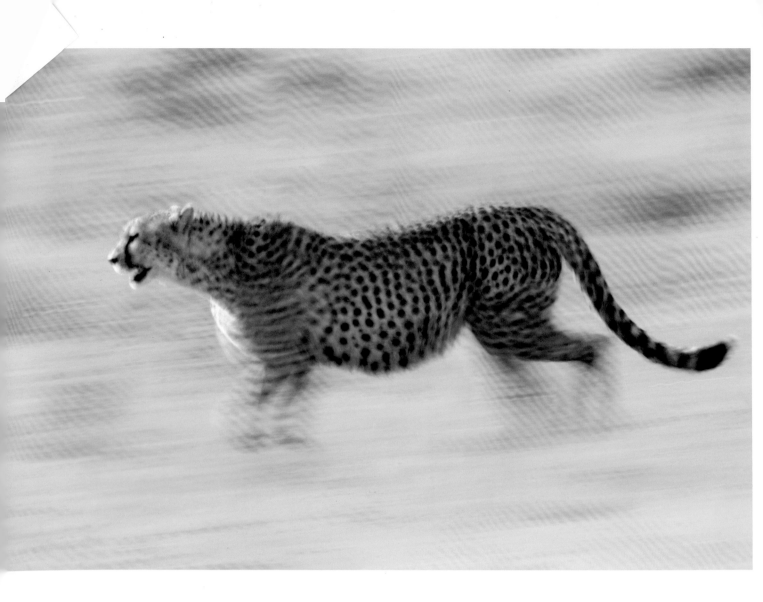

Panning

The most popular technique for adding a moment of motion to a still photo is probably panning with a moving subject. Panning involves tracking the subject in the viewfinder and shooting during the tracking process. It always works best when the action is moving across your field of view, as opposed to towards or away from you. For most of us, the ideal panning shot shows a lot of movement in the background and maybe even parts of the subject, but usually includes some part of the subject that is sharp for the eye to rest on. I say "usually" because some of the best panning shots I've seen have been complete impressionistic blurs. It all depends on the subject matter (not to mention the viewer's tolerance for abstraction).

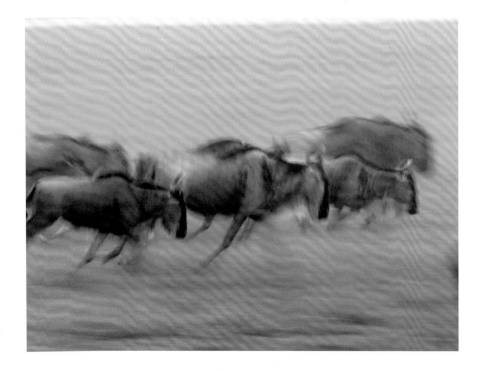

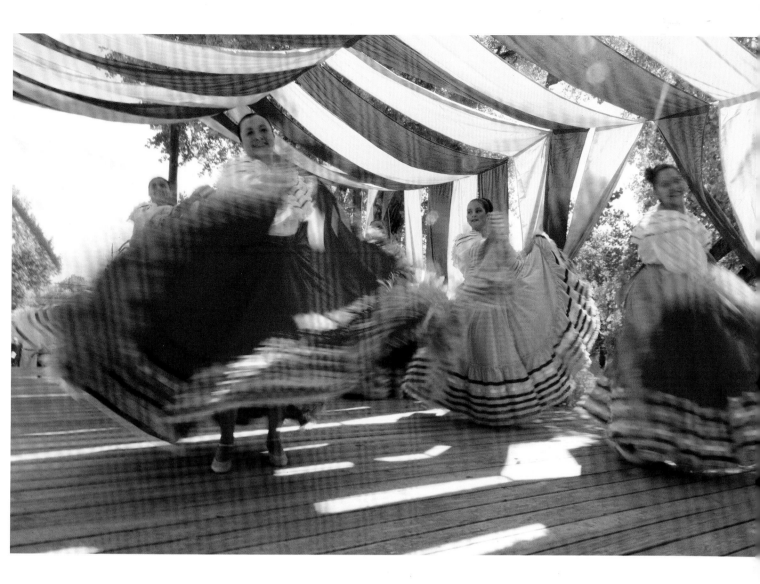

For horseback riders, bicyclists, runners, and other fast-moving subjects, a zoom lens in the range of 70 – 200mm is ideal, and a good useable shutter speed range for a good combination of blur and sharpness (for me) seems to be in the 1/15th – 1/60th second. Any shutter speed slower than 1/15th, and it's difficult to get anything sharp; anything faster than 1/60th and it's hard to retain the feel of movement.

Panning technique requires you to smoothly follow the subject in your viewfinder by twisting your upper torso and—this is important—to continue to follow through with that motion after you've banged off your frames. Think of a baseball player at bat: he or she

will not stop the swing once they've made the connection with the ball; they continue to follow through with the movement.

Back in the film days, when it cost some serious bucks to experiment with techniques, I used to practice panning by shooting without film. If the subject was in the same relative position in my viewfinder after the series of exposures as it was when I started shooting, I could be relatively assured that I had successfully matched the speed of my panning to the speed of the subject. These days, of course, you can see your results immediately and there's no worry about burning up film (and dollars) on experimentation. The more you practice, the higher the percentage of keepers you'll have.

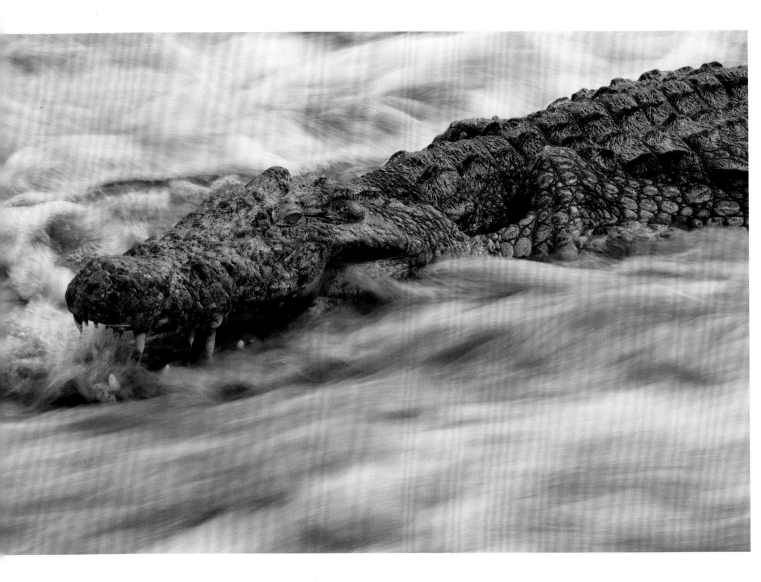

Sometimes, there's just too much light around to get a slow enough shutter speed for panning. That's when the neutral density filter comes in handy (see page 62). The Singh Ray Vari Neutral Density filter is especially useful because its variable two to eight f/stop range lets you dial in enough neutral density to get just the right shutter speed for the job (www.singh-ray.com).

Panning is a good option for moving subjects, but travel, outdoor, and nature photography also presents the opposite, less-obvious, scenario: a static subject with a moving background.

Sometimes you can take what appears to be a liability—that moving subject which you'd prefer to be static, like a field of wildflowers blowing in the wind—and make it an asset. Instead of trying to freeze the field of flowers, go the other way and use a tripod and really long exposure, and reduce them to waves of impressionistic color.

On a recent trip to the Galapagos, I came across some cooperative Sally Lightfoot crabs at the end of the afternoon in the fading light. Rather than try to track the colorful creatures scampering across the rocks, I put the camera on a tripod and concentrated on

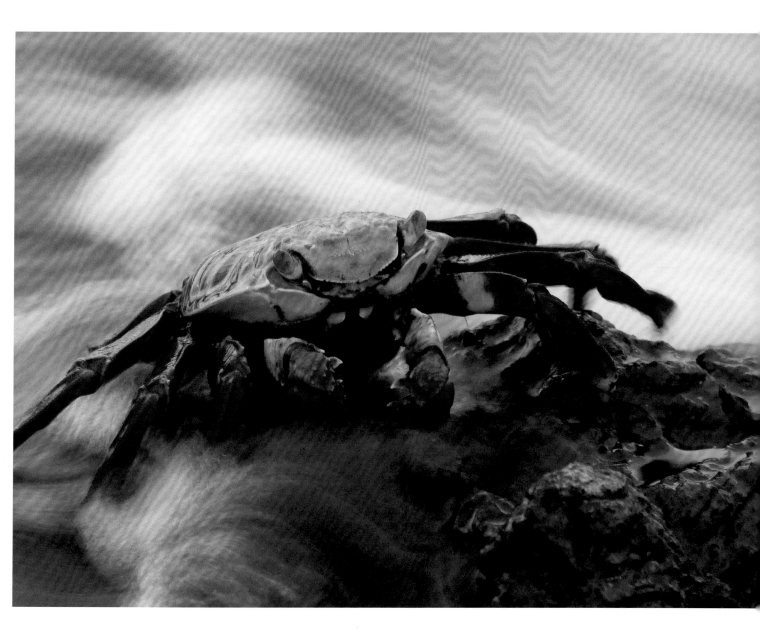

the static ones near the water's edge. I cranked the shutter speed even lower to record the movement of the waves as they washed over the clinging crustaceans.

Similarly, when I encountered a croc in the waters of the Grumeti River in Tanzania, sitting stock still in the rapids of a small waterfall with his mouth open waiting for fish to just swim into his craw, a slow shutter speed helped to capture the situation.

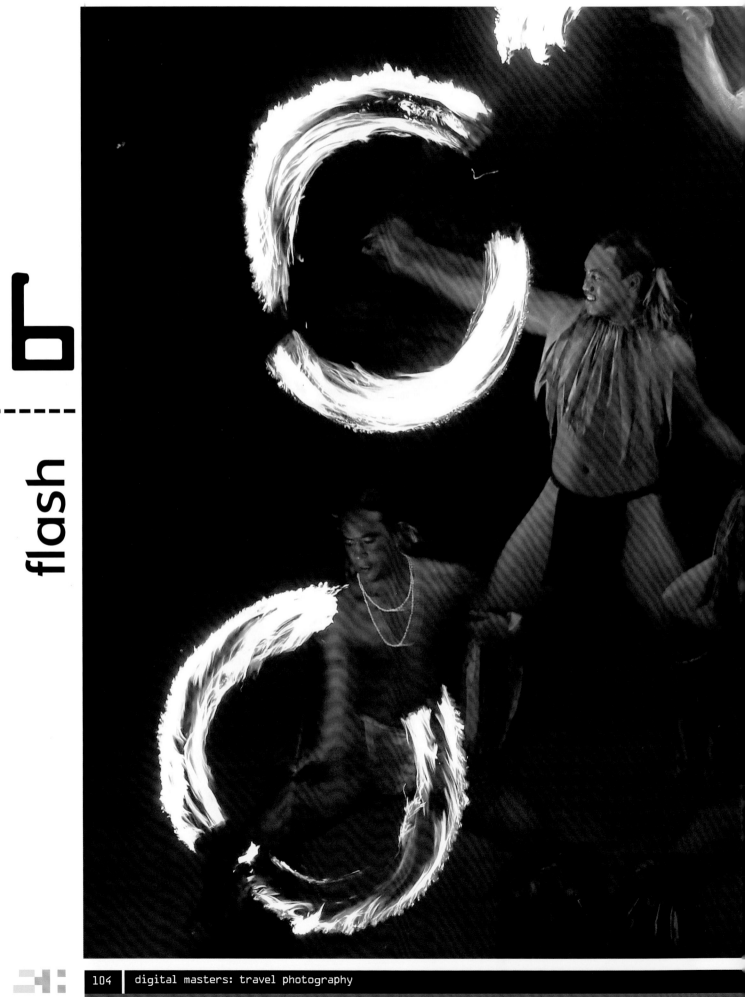

flash

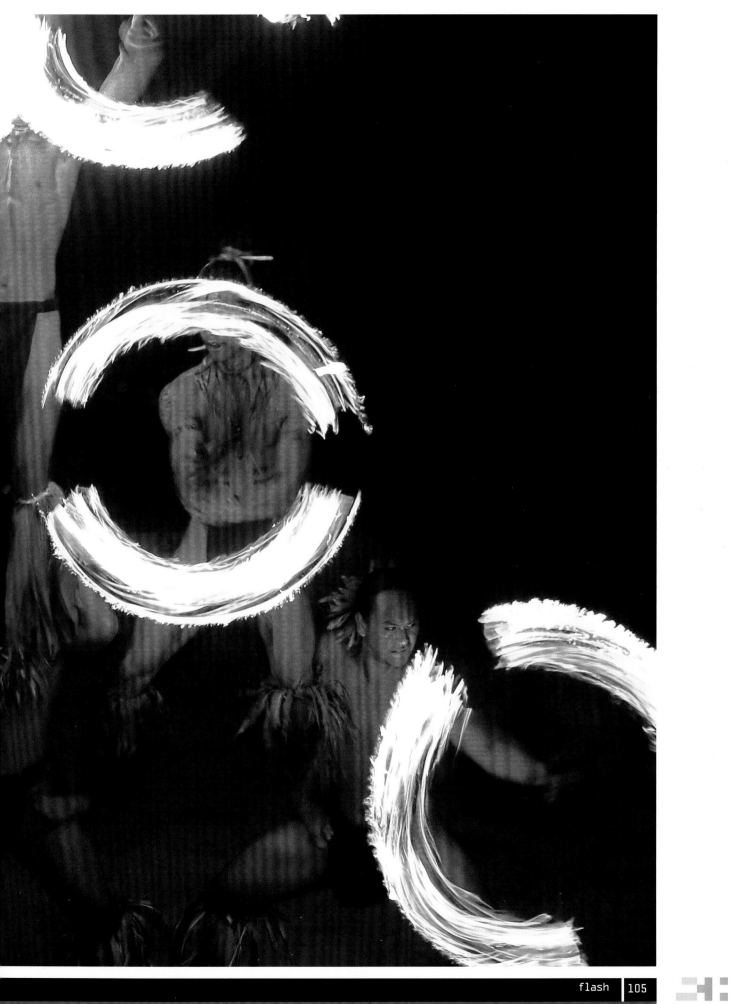

Flash

A small, shoe-mounted electronic flash unit is the accessory that photographers love to hate. Everybody has one, but it is the rare shooter who really knows how to get the most out of it. Most are satisfied to leave the flash in the hot shoe and blast away in the dark. Satisfied, that is, until they see the results: washed out skin tones and startled expressions on ghostlike figures emerging from a sea of darkness. It's enough to make a street-hardened paparazzi hand in his press pass.

To overcome this look, serious photographers have traditionally added more flash units to light up backgrounds and surroundings. These big, powerful lights are anything but portable—not the ideal solution for a photographer interested in traveling light.

There are ways, however, to make a small flash unit work lighting miracles. By blending, bouncing, angling, and otherwise maneuvering this highly controllable light, you can improve the look of your flash pictures and stretch the scope of your photography. Once, these techniques took a great deal of technical skill, but the current crop of D-SLR manufacturers offer cordless TTL (through the lens) evaluative flash technology that can blend seamlessly with available light, and make it far easier to achieve advanced results.

Automated flash technology wasn't always this easy or flexible. The first automatic flash units had an onboard sensor that read the light reflected off the subject and quenched the output of the flash when it determined that enough light had been put out for the selected aperture. Automated flash was a quantum leap from straight manual flash, but could be fooled if the unit's sensor didn't "read" the scene properly or if the subject was much darker or lighter than normal.

The next stage of the evolution was TTL flash. Now, the camera could read the flash exposure right off the film plane, which greatly improved exposure accuracy. However, flash exposure and ambient light exposure were two different things, and there was no way for the camera or the flash to measure both at the same time.

Enter the age of evaluative TTL flash, which came in with autofocus cameras. Now, depending on which mode you chose, the flash can either act as your main light source, it can serve to open up shadows, or it can blend with the available light in the evaluative TTL mode. This ability was nothing short of revolutionary, but was overshadowed by all the hoopla about autofocus.

Finally, with the advent of digital technology, flash technology took another quantum leap forward. Now, the evaluative TTL works by reading a preflash emitted from the camera to judge the exact amount of light needed to correctly expose the scene. Combine this with a flash system that can be controlled cordlessly from the camera, and for flash users it's a whole new ballgame.

Blended Flash

Despite the forward leaps in flash technology, it still helps to know the "why's and how's" of using evaluative TTL flash. To do that, it's worthwhile to go over some basics of flash.

Two variables control how light enters the camera: the aperture we've selected on the lens and the shutter speed (or the amount of time the shutter curtains). Because flash is such a quick burst of light—lasting anywhere from 1/1000th of a second to about 1/50,000th of a second—the shutter speed really doesn't affect the flash exposure, except in one way.

The flash must "synchronize" with the curtains of the shutter so that it goes off when those curtains are fully opened. While today's shutters may go up to speeds of 1/8000 second, a second, most flash units are not capable of achieving that "synchronization" at speeds higher than 1/250th, or in some cameras, 1/500th of a second.

What happens if the flash goes off and the camera's shutter speed is faster than the top "sync" speed? You get incomplete lighting from the flash because one of the shutter curtains is already partially closing as the flash fires, and this results in a half or quarter of the frame looking black or much darker than the flash illuminated portion. It is important not to shoot flash when your shutter speed is set for higher than the maximum "sync speed."

(Above) A pop-up flash and normal sync speed (1/125 second) creates a very stark picture without any feel for the ambient light from the candles. (Below) Using the same pop-up flash but setting the camera to "slow sync" slows the shutter speed down (1/4 second) and registers the warm light of the candles to create a photo with more atmosphere and mood.

But many people feel somehow obligated to use that top sync speed whenever they use flash. What they don't realize is that the camera will synchronize at much slower speeds as well.

Why might you want to use a shutter speed that is slower than the maximum sync speed? Well, the light from flash units "falls off" very quickly, meaning that it doesn't go far and its power diminishes exponentially as it travels further from the source. This is called the Law of Inverse Square, which purports that "light falls off at the square of the distance." In simpler terms, this means if you double the distance between your flash unit to your subject, your subject only receives ¼ the amount of light; if you quadruple the distance between the flash and the subject, the subject receives 1/16 the amount of light. This is true for any light source, but is especially challenging with small, shoe-mounted flash units—the best you can do with these is light the area in proximity to the front of the camera.

What happens, though, when you have a dark scene with some depth to it? These situations arise all the time in location photography. Take, for instance, a portrait subject sitting in a large room, or a statue in the great hall of a museum. No matter how you modify the light from your flash—bounced, diffused, or whatever—if you shoot at the camera's highest sync speed you'll still end up with a harshly-lit subject swimming in a pool of darkness.

By using a slower shutter speed, one closer to the scene's available light reading, you can blend the two light sources—the ambient light in the scene and that of the strobe—to create a picture that exposes both the foreground subject and the background correctly.

Instead of shooting a flash picture at 1/125th of a second, try shooting the same picture at 1/8th, 1/4, or 1/2 of a second. Suddenly, details in the background become visible, creating much more natural-looking pictures; lamps look lit, computer screens are no longer blank, and candles and fireplaces emanate their expected glow. In conventional flash pictures, at higher sync speeds, the background is almost always rendered as a black hole with no detail whatsoever.

How important is this technique? Almost all my indoor flash, outdoors at night, and dawn or dusk images involve blending available light with flash. There is no better way to achieve natural looking, yet well lit, pictures. Blending has become a widespread technique since camera manufacturers built this function into their digital flash systems. It's usually called slow sync, night mode, or always-on flash, and once this mode is set, flash blending is done automatically. (Refer to your camera's guide or manual for specific instructions on applying the slow sync flash function. Most cameras accomplish this in slightly different ways.)

There are several things to be aware of when you are blending flash with ambient light. The first and most obvious one is that, because using a slow shutter speed is necessary to capture the ambient light, you need a tripod to assure sharpness in both the background and the foreground. Similarly, any movement by your flash-lit subject in the foreground will result in blur and "ghosting" of the image.

The "Shake and Bake" Technique

Many shooters still prefer to do much of their blending by panning with the subject's movement using a handheld camera because the blurring of the background and the "ghosting" of the flash image actually adds a sense of movement and energy to the photograph. It's a great technique, used frequently in photojournalism, and photographers have pet names for it: "strobe and burn," "shake and bake," and "dragging the shutter," are but a few. This technique essentially combines slow sync flash—where the shutter speed slows to record the low level ambient light in the background—with the motion of panning.

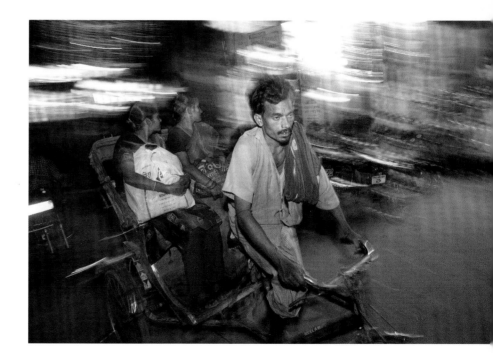

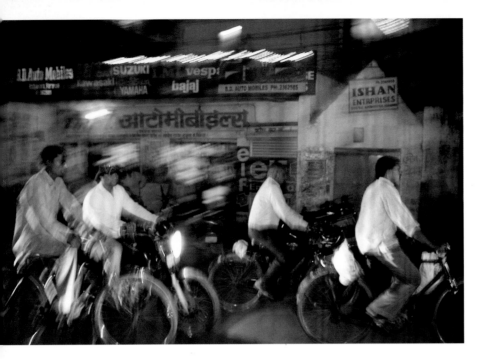

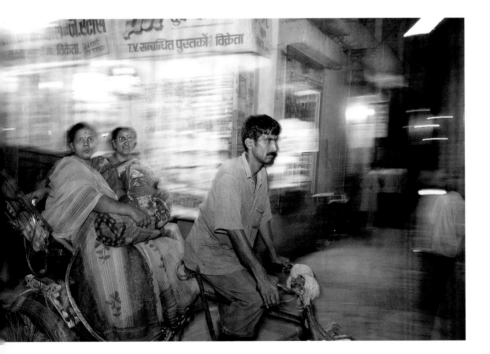

For this technique to work well, you need background scenes with evenly dispursed ambient light (even if it is low level light). Panning and flashing, say, a horseman riding against a darkened prairie will probably not work as well as shooting a bicyclist on a brightly lit street in India. The background lights are the things that "drag" and help to indicate movement. Shutter speeds in the 1/8th, 1/15th, and 1/30th of a second range are especially good for achieving this effect.

The "shake and bake" technique is almost always used with normal to wide-angle lenses. This is due to two things: the relatively weak output of most shoe-mount flashes, and the fact that it is much harder to pan accurately with a wide angle than it is with a telephoto lens (something about the difference of the relative size of the subject in the viewfinder I'd bet). But whatever the reason, it is harder to match the speed of the subject with a wide angle, and thus the action-stopping burst of light from the flash helps to raise your percentage of keepers.

The effect of motion is somewhat lessened with a wide-angle lens than it is with a telephoto because of its larger angle of view. In order to create the movement effect with a wide angle, you must use slower shutter speeds. I find my usable range of shutter speeds drops from about 1/4 or 1/8th of a second to about 1/30th—any slower and large parts of your subject, frozen with flash, can actually disappear during the long ambient exposure. Using shutter speeds faster than 1/30th, you just don't get much feel of blur in the background. It is a creative choice.

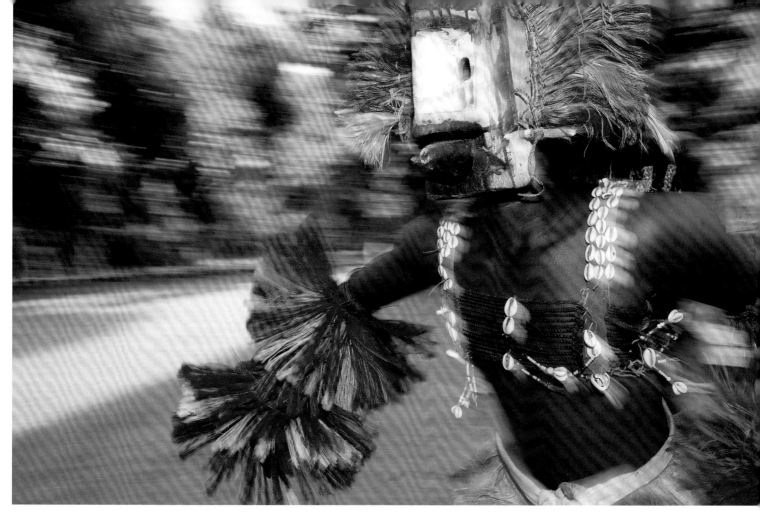

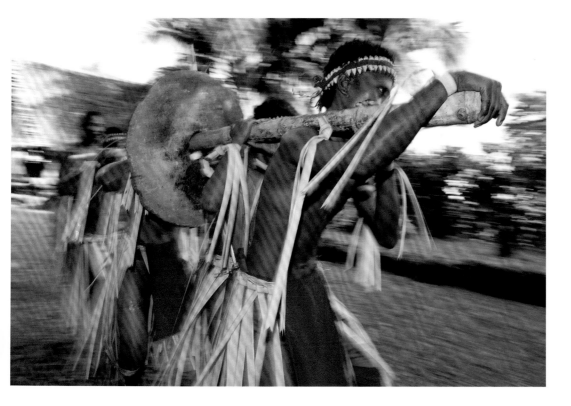

On the Road: Rear Curtain Sync

Unless you specify "rear sync" or "second curtain sync" on your camera and/or flash unit, your flash unit will fire as soon as the shutter curtains are open. This is called first or front curtain sync. At faster sync speeds of 1/125th, 1/250th, 1/60th of a second, you won't see a difference between these two options.

However, the same is not true for slower shutter speeds (say 1/30th, 1/5th, 1/8th of a second, or slower). At these speeds, the sensor captures a fair amount of the ambient light, and timing the flash burst makes a significant difference in the look of the picture.

If you are panning with a moving subject, using a slower shutter speed, and the flash is set for front curtain sync (the automatic setting on most cameras), the flash will fire first and the shutter will remain open for a bit more while you pan. The result is that the blur lines will appear to be in front of the direction of movement of the subject. But years of visual conditioning have taught us that to signify movement in a certain direction, the blur lines should appear behind the subject, not in front of it (unless, of course, it is moving backward).

This is where "rear" or "second" curtain sync comes in. By causing the flash to fire at the end of the exposure, rather than the beginning, the blur lines are registered before the subject is frozen by the flash, thus appearing to follow the subject. The path of movement looks more logical to the viewer's eye.

This sounds great in theory—blur lines behind instead of in front of the subject—but in practice placing the subject accurately is a bit different. Why? We normally press the shutter button when we see the composition we like, when the subject is in the part of the frame that we want it. Combining longer shutter speeds and rear curtain sync often creates enough of a delay that the subject is in a completely different part of the frame when the flash finally fires, and the resulting image is not what we had in mind when we clicked the shutter. It takes some practice, as with any other flash technique.

I was shooting a story in Toronto when rear sync was first introduced. One of the nightlife situations I covered was a street of neon and nightclubs down which the glitterati of town would cruise in their fancy convertibles: a perfect situation for rear sync! I envisioned a fancy red Lamborghini with blur lines behind it and a background of colorful neon. In practice, I would press the shutter when the composition looked good, but by the time the flash went off, the car was often out of frame. I had the blur, but not the car.

In real-life situations, the best advice I can give is to anticipate where the subject will be in the frame when the flash fires and not be concerned about where the blur lines occur, as long as they are present to indicate movement.

Fill Flash

Strangely enough, the camera's fastest flash sync speed—the fastest shutter speed that allows the flash to go off when the shutter curtains are still fully opened—usually comes into play when you think you wouldn't ever need to use a flash: on a bright, sunny day. That bright, mid-day sun is the kind of light that produces very contrasty conditions: bright highlights and deep shadows. Those shadow areas, although they may look "open" to the human eye, are often rendered as annoying shadows with absolutely no detail.

No flash technique is more misunderstood and subject to misinterpretation than fill flash. The technique is similar to blending, but in this case, the primary light source is the sun and the flash is used only to "open up" the deep shadows in the scene (for instance, those cast over someone's face by the brim of a hat). If the sensor could see detail in the shadows the way our eyes can, there would be no need to lighten up those shadows.

Fill flash used to require more calculations than a trigonometry exam, but these days, all you need to know is how—and when—to turn on your flash unit. The camera and flash unit do the rest.

Previously, an electronic flash's exposure system, whether automatic or TTL, only controlled the unit as the main light. If the flash was the main source of lighting in the picture, these units worked perfectly. Today's flash units can do all this, but most manufacturers have added a function where the camera's meter reads the contrast range in a scene and controls the flash exposure to supplement the shadows, thus lowering the

contrast. In other words, the advanced flash can also function as a "fill light," with the available light used as the main source of illumination. The sophisticated multi-segment camera meters and evaluative flash systems are uncannily accurate in their ability to provide perfectly balanced fill flash in a variety of situations.

At first blush, this doesn't sound like such great shakes. But in practice, the ability to put out absolutely seamless, worry-free, and perfectly balanced fill flash without complicated calculations is a tremendous boon. You can create well-lit, professional level photographs in far less time than previously required.

Most advanced flash systems still allow for some input from the photographer. For instance, many professional photographers find the fill flash settings provided by the factory to be a little "hot," meaning the unit provides a bit too much output in the fill mode. Fortunately, with some cameras or flash units, you can dial in a flash exposure compensation of plus or minus up to two stops. This manual control is very helpful, especially when used in complicated lighting situations that might trick your camera's light meter, skewing the exposure reading.

If you check your results on your LCD screen and the picture still looks a little "flashed," dial down the amount of flash the unit is putting out by using the flash exposure compensation dial on your camera or flash unit.

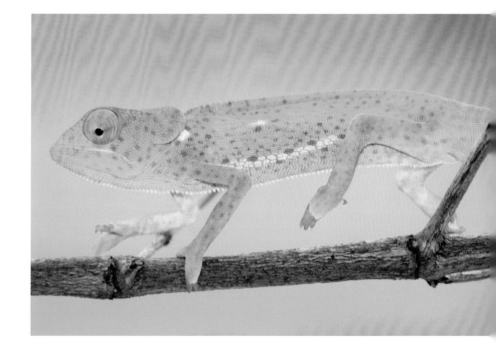

Bounce Flash

Basically, bounce flash is a flash diffusion technique that works exactly how it sounds. It involves aiming the flash at a broad, light (preferably white) or neutral-colored surface—usually a ceiling or a wall—and "bouncing" the light off that surface to light the subject. This gives a nice softness to the direct light emitted from a flash unit—gone are the harsh shadows and hard specular light; in its place is an even, natural-looking light that appears, for all intents and purposes, to be available light.

There are a few things to remember when using the bounce flash technique. Because the light is traveling farther in addition to being diffused, bounce flash requires more output than direct flash, and it might take longer for your flash unit to recharge. If you bounce the flash off of the average 8 – 10 foot (2.4 – 3 meters)white ceiling, you can expect to lose 2 – 3 f/stops of light. Advanced TTL flash systems adjust for this automatically, but even so, if you are accustomed to using apertures in the f/8 – f/11 range when shooting direct flash, be prepared to use wider apertures (f/2.8 – f/5.6) when bouncing the flash.

Also, be very aware of the color of the surroundings when bouncing flash—a light green ceiling will make your subject look seasick and orange walls will give that instant sunburned look to skin tones. If you are caught in a room with dark or off-color walls and ceilings, don't give up—just improvise. Several pages of a broadsheet newspaper taped together and taped to the wall or ceiling will give you a nice bounce surface. Rosco sells 48 x 56 inch (121.9 x 142.2 cm) sheets of reflective material—gold, silver, or white—that fold into a pocket-sized plastic pouch and weigh only a few ounces. These are called Roscopaks, and can be taped up to any surface, providing 18 square feet (5.5 square meters) of bounce surface (www.rosco.com).

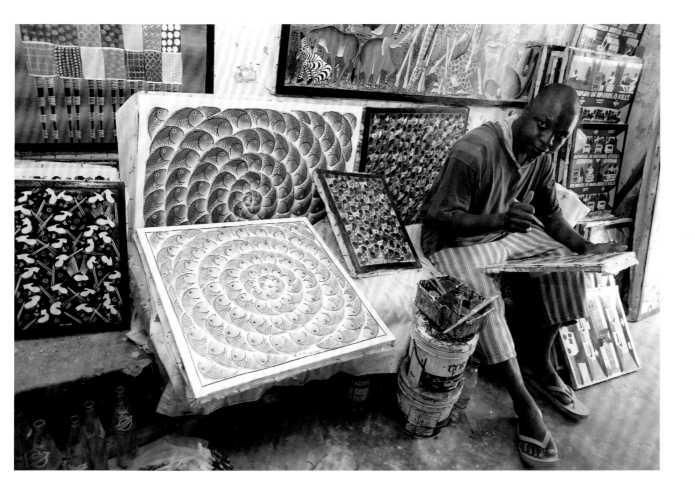

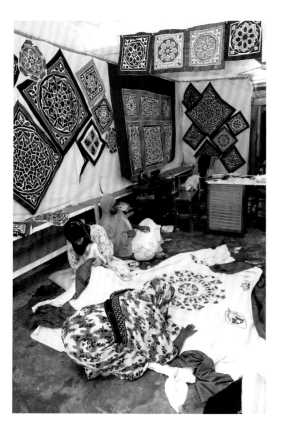

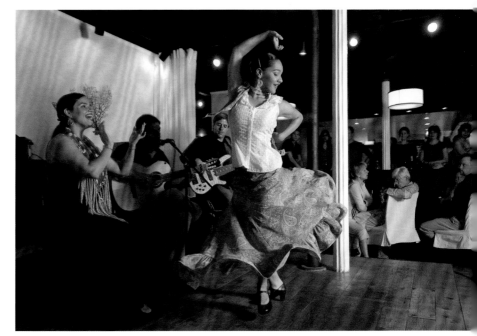

Diffused Flash

There are occasions when the ceiling is off-color, too dark, or too high for bouncing a flash. Not to worry—there are still alternatives to direct flash. In recent years, several manufacturers have come up with compact, inexpensive, and portable diffusion devices for on-camera flash. These accessories, while preferable to direct flash, are limited in their diffusion power by their small size. No matter what the ad copy may promise for these diffusers, there is one truth regarding lighting that cannot be circumvented: the larger the light source (in relation to the size of the subject) the softer the light. Let's illustrate this with an example: a small, clip-on softbox may provide a nice, even wraparound light for a macro subject like a butterfly, but to achieve that same light quality in a group portrait of five or six people, you'd need a light source as big as a king size bed sheet.

Nevertheless, this is a case where something diffusing the flash is better than nothing at all. Some flash units, like the Nikon SB-800, ship with an accessory translucent plastic dome that fits over the reflector of the flash, creating a 360° spread of light. This is the accessory to use when you have a wide-angle lens on the camera; even the widest fisheye lenses will be covered. These little diffusers work best when there are light colored surfaces around off of which the scattering light can bounce.

LumiQuest makes a series of "Pocket Bouncers" which are essentially small bounce surfaces that attach to the flash with Velcro. A wedding photographer named Gary Fong also has a series of on camera diffusers called "Lightspheres" (www.garyfong.com), which are larger than the Pocket Bouncers and are excellent diffusion domes.

Any of the diffusers mentioned above will do a serviceable job of softening the light of an on-camera flash.

Off-Camera Flash

With many of today's D-SLRs, you can detach an accessory flash from the camera's hot shoe and still control the light output and exposure—wirelessly. It used to be necessary to run a network of cords for off-camera flashes to talk to each other and the camera, resulting in an awkward web of wiring that just invited people to inadvertently walk into them and pull them apart.

Most wireless, off-camera flash (also called "remote flash") is controlled either by the camera's built-in flash or a flash unit mounted to the hot shoe referred to as the "master flash," or by a dedicated controller (also called a wireless "commander") mounted to the hot shoe. (If you use a flash unit as the control device, it can create flash output to light the scene as well; a wireless commander does not emit any light—it simply controls the remote units.) Signals sent via infrared light from the master flash or wireless commander unit instruct the remote unit(s) on how to operate, and the camera monitors the flash output and controls the overall flash exposure.

The flexibility of wireless flash is immense. Some systems, use the built-in flash as a control unit for up to several flashes. Flash units can be "ganged" together (meaning you can adjoin several flashes to create one wireless "unit") and used as three separate groups, can be fairly far away from the camera (up to 30 feet (9.1 m)), and the output of these single or multiple units is controlled directly from the camera! That's an incredible amount of control and customizing, all done without the use of actual wire.

At first blush, you might wonder, "What's the big deal? It's just a cord after all." But in real world situations, not being tethered to your

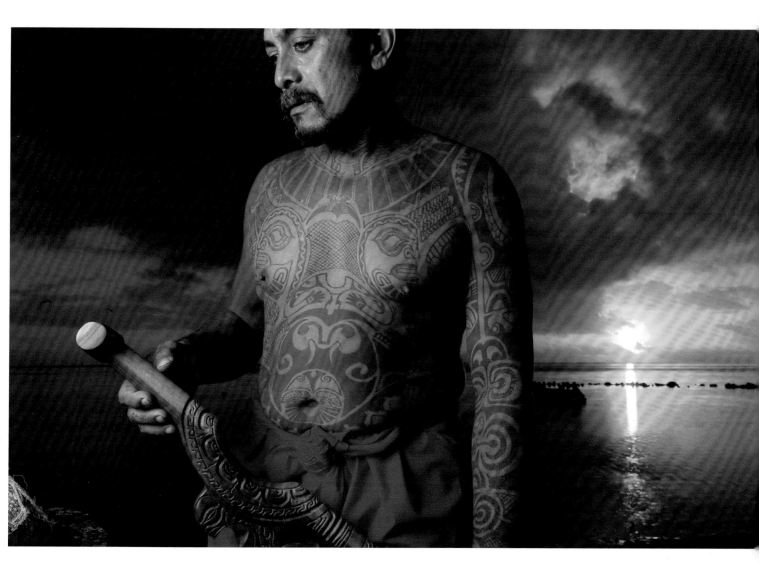

TTL flash units opens up a myriad of creative opportunities that previously required spider webs of connector cords or sacrificing the TTL control and to go to a cordless manual exposure setup (complete with using slaves, radio controls, and flash meters).

There are many advantages to using off-camera flash. First, you can create a true side-light—it gives form and texture to your subject, primarily by creating shadow areas. The resulting image has a much more three-dimensional quality than one which has been lit by straight on-camera flash. I'm often surprised by the quality my direct flash pictures have when the unit is held off camera—at

times, it almost looks as though the light was diffused through a softbox or bounced into an umbrella.

Off-camera flash also gives you another effective means of diffusing your flash. Connect the flash unit to a small umbrella bracket, such as those made by the Morris Company (www.morriscompany.com), and shoot the flash into or through a small white umbrella. With a 20 inch (50.8 cm) white umbrella (the "Totabrella" from Lowell Light; www.lowel.com), I can hold the entire rig in one hand while working the camera with the other. This is an extremely portable setup that produces beautiful light.

On the Road: Flash and Color Temperature

Most flash units are color balanced for 5500K—the same cold, bluish light present at high noon. To counteract this, many pros "warm up" the light from their flashes by covering the reflector with a warming gel filter. I have a Roscolux 02 Bastard Amber gel on all my flash units. Filter swatch books, available for a few dollars from manufacturers like Rosco, are the perfect size for most shoe mount flash units. These books will allow you to experiment with different warming filters until you find one you like, as well as providing countless colored filters for special effects.

Another quick way to counterbalance the blue/white color of the flash is to simply set your camera's white balance to the "flash" setting. This is one of the warmest white balances, and gives the skin tones lighted by flash look a warmer and more natural look.

Practice Makes Perfect

Like any other aspect of photography, the more you practice your flash technique, the more ways you'll find to put it to use. Hopefully, you've picked up a few new pointers to help shed light on your subjects during your travels. You'd be surprised at how quickly the accessory you love to hate will become the tool you wouldn't dream of leaving home without.

photographing people

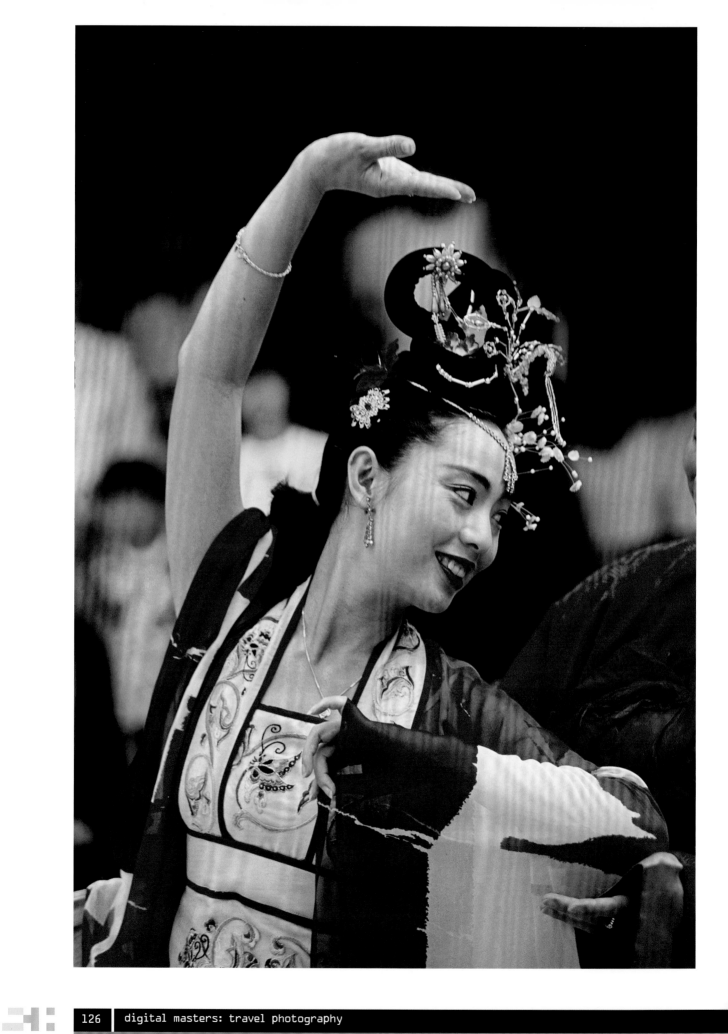

The Approach

At many of the workshops and seminars I teach, the first question that is often asked is, "How do you approach a stranger for a picture?" The questioner then usually mentions his or her shyness, and the awkwardness they feel when they attempt it. The bad news is that most of us veteran people shooters feel the same way. The good news is that it's a curable condition! However, it does takes some gumption to overcome shyness and inertia and reach out to engage with a stranger.

Professional photographers have an advantage in this regard because there is a clear-cut mission—a photo assignment. Left to my own devices, I'm a shy person, preferring to keep to myself. Knowing I have to produce a publishable story, however, helps propel me headlong into my new and unfamiliar surroundings (and I'm always thankful later when I'm looking over my photographs). But what if you don't have a demanding photo editor waiting to see your "take?" Can you overcome inertia under your own steam? You can, if you give yourself a "mission."

When you have a purpose or a mission, not only will you be more motivated, but so will the people you meet. If you approach a stranger on a street in Paris or Podunk and ask, "Can I take your picture?" they are likely to refuse. But if you share a little of yourself—explain that you are doing neighborhood portraits for, say, an educational slide show for your child's geography class, or you're shooting for a photo exhibit at your local community center, or even as "homework" for a photo class—you'll be surprised at how often complete strangers will agree to pitch in and help.

Now your potential subjects know just what you're up to, you've demonstrated a genuine interest in them and their world, and it's easier for them to sign onto your project. On your end, a definitive theme or assignment helps you focus your concentration and make you more pro-active in seeking and capturing interesting people photographs.

Photographing People: The Art

Gesture

Portraits and people pictures can also benefit from a sense of moment. Most of the time, this takes the form of a characteristic or significant gesture by your subject. A "gesture" doesn't necessarily mean a literal hand movement (although they certainly qualify). Rather, it means an action—a facial expression or a certain posture—that gives a momentary insight into your subject's mood or character.

I remember photographing an old man in a tiny pub in the middle of Transylvania. He was telling a story to the other patrons, feeling no pain. Although I didn't understand one word of what he was saying, he would occasionally punctuate his narrative with hand gestures and plaintive looks up into the eyes of his audience. I observed his rhythms and was able to time—just from his inflection, body language, and tone—when the key gesture would come. I was primed and ready to capture this decisive moment, even though I couldn't understand a word the man was actually saying!

But what if it's a portrait situation and you're "directing" the subject? How do you elicit the decisive gesture from them? The key is interaction. You have to give your subject something to respond to—conversation, some posing instructions, a wisecrack or a joke—and you must have the camera up to your eye, ready to capture their reaction. Ironically, a working knowledge of the language is great, but not required, because it's often your tone of voice and body language that helps to calm the subject and elicit honest reactions. Those reactions may be singular and momentary, however, and this means that you must have not only a sense of anticipation, but

also a good working knowledge of your camera's operation. Otherwise, those fleeting expressions and gestures will be lost while you fiddle with the controls. Talking to someone with a camera to your eye may seem a bit awkward at first, but after a while both you and your subject get used to it. If I am photographing a particularly shy or non-responsive person, I will often make a joke or a wisecrack with the camera glued to my eye to make sure to catch their unguarded and hopefully smiling response.

Sometimes, especially if the photographer falls silent and stops interacting, an inexperienced photo subject will "freeze up" on you, and go into what I like to call the "firing squad pose"—a glazed expression, hands at their sides, standing straight up on two feet—the kind of body language that says, "Shoot me now, and put me out of my misery!"

The only time people should stand with their weight equally distributed on two feet with their hands hanging by their sides for a picture is when they're awaiting a chest X-ray or a mug shot! Get your subjects to lean, prop one foot up, put their hands on their hips—anything to break up that straightforward mug shot. A relaxed posture usually means leaning on one foot or the other. Sometimes, you may need to actually demonstrate the relaxed posture in order for your subject to grasp what you're saying.

A prop can help relax your subject, give him something familiar to which he can relate, and help him concentrate on something other than the camera (which, to many people, is somewhat intimidating). A golfer leaning against her driver, an animal lover with his pet, a farmer with his rake or hoe—anything to occupy the hands of your subject to keep him relaxed.

Eye-to-eye portraits are fine, but you can occasionally create some extra interest or impact by getting lower or higher than your subject. A lower point of view makes your subject appear more dominating or important. A higher point of view creates a more friendly or approachable impression. Portraits of children are especially effective when shot from their eye level rather than yours. You'd be surprised at how different the world looks from their perspective!

Another idea is to go back to the visual homework method. Most magazines today run portraits of celebrities and newsmakers in their own environment. The photographers that set up and shoot these layouts are master of creative posing and body language, and this is a wonderful way to research and study images for posing tips.

Candid vs. Posed

I don't have hard and fast rules as to which is the preferable way to photograph people, candidly or posed. For me, it's strictly a question of "situational ethics." If I see a wonderful little slice of life being played out on a corner in Rome or Rhode Island, I'll try to grab it with a long lens, perhaps, so I can stay out of the equation and capture the moment that way, without the participants ever being aware of my presence. That's the ideal scenario.

On the other hand, I may wade into a crowded street with a wide angle and try to grab street scenes, getting up close and personal with the wide-angle perspective. And at any time, if I see someone with whom I think I'd like to work, I'll approach them, make contact, share my assignment, and hopefully walk away with some nice environmental portraits.

I do find that the less experience the photographer has, the more he will tend to shoot candids and nothing else. This, of course, is a limiting factor in the types of people pictures and personal encounters you'll have, so I recommend overcoming the inertia and reaching out to people in your travels. Both you and your photographs will be the richer for it.

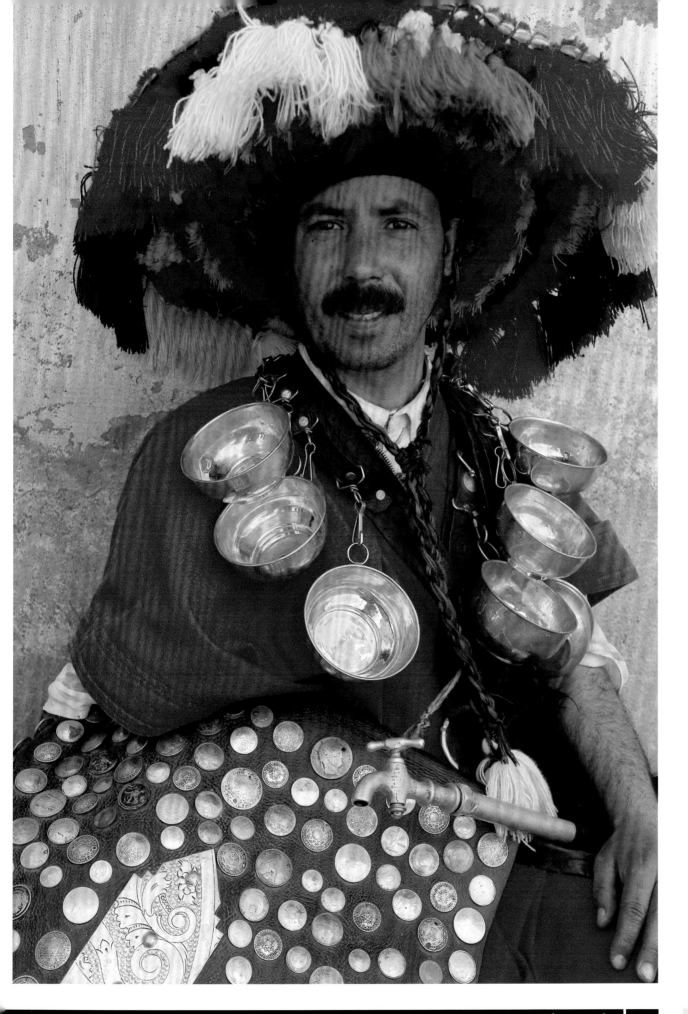

On the Road: Photography and the Law

We live in the most litigious society on earth, and produce images that are whipped around the planet on the Internet, subject to being co-opted, misappropriated, misused, or objected to, in real time. The legal aspects of making and displaying images—once the exclusive headache of professional photographers—is now a concern for every photo enthusiast who shoots a picture on the street or in a park, posts it to a website, or puts a print on display. The questions raised are legal inquiries: When do I need a signed model/location/etc. release form? What protection do I have under the copyright law? How do I prevent infringement? Where and when am I allowed to take a picture? It's enough to make you jump up and say, "I object, your honor!"

Short of adding "intellectual property lawyer" to your resume to answer these questions as they arise, what's a shooter to do? Fortunately, there's a more reasonable alternative to going back to law school, and it comes in the form of attorney and photographer Carolyn Wright, author of Photographer's Legal Guide (www.photoattorney.com). She helped me understand my legal rights and responsibilities as a photographer in language that doesn't require a degree from Harvard Law to understand.

I recently caught up with Carolyn, an attorney and avid part-time professional photographer who leads nature and wildlife photography workshops and shoots portraits and events, to ask her a few of the key questions.

Bob Krist: Carolyn, a question I'm always asked in seminars and workshops these days is, "When do you need a model release?" Is there any shorthand answer to that?

Carolyn Wright: Well, the shorthand answer is, "If your client requires a model release, then you need one!" [Laughs]. Legally, the answer is a little different. You only need a model release for commercial usages, not for editorial uses. Basically, a commercial use is when a photo of a person is used for an advertisement or endorsement or used in "trade." Trade is when photographs are put on an actual product, such as a tee shirt, coffee mug, a lunchbox, or something like that. But just because you sell a photograph doesn't make it a commercial use. It gets a little sticky at that point, and sometimes it's a gray area as to what exactly is an editorial use and what is a commercial use, but that's when we look to previous court case rulings to make the distinction.

BK: I know, as a longtime magazine freelancer, that most magazine and newspaper usages are considered editorial uses and, as such, don't require model releases, but even these lines are blurring—the safest thing to do is to get a model release whenever possible. I've been asked a lot lately if a model release is required to sell fine art prints in a gallery. Is there any precedent there?

CW: There was recently a ruling about an artist who photographed people on the streets of New York and had a gallery show of the prints. There was a man who was photographed and later objected, for religious reasons, to his photo being sold as a print and appearing in a book, and he sued the photographer because the photographer did not have a model release. But the courts determined that, even though the photographs were sold, they were regarded as editorial or fine art use and not a commercial use because the image wasn't used to sell or endorse any product. That was a very important recent indication of what the courts would consider an editorial use.

BK: Now, in the post 9/11 high security era, we're hearing more and more about photographers standing out on the street shooting a building or a park and security guards or police coming out and saying, "You can't photograph here." Are there any guidelines for where you can and can't make photographs in public places?

CW: Generally, if you're on public property or in publicly accessible spaces, they shouldn't be able to do that. Now they can ask, if you have your tripod setup and you're blocking access, say, that you pack up and move. But if you're in a public place you should be able to shoot. Whether you want to go to jail in the process of fighting for your rights is another question you have to ask yourself. You can be within your rights but still severely inconvenienced in the process of exercising those rights. And, there are some sensitive governmental facilities that are usually fenced off and you might have a real uphill battle in those cases, but in most public places, there is no law against photographing.

K: Sometimes you can be polite and sweet talk them, but sometimes you have to dig in your heels. But what if you're on private property, what then?

W: If you're on private property, you have no recourse because a property owner can prohibit you from doing anything they find offensive, from spitting to playing loud music. They have the right to control what happens on their property, just as you have in your home. But on public property, the standard question is, "Would they be able to prevent you from doing what you're doing (i.e. standing there quietly) if you didn't have a camera in your hands?" If not, then they probably don't have the right to prevent you from photographing.

K: Let's talk a bit about copyright. I know that photographers are afforded two levels of protection under the copyright law. If you publish or display a picture with the © and your name and date, you get a minimum level of protection, but for full copyright protection, you need to take it one more step.

W: You are afforded some copyright protection by the symbol, but in cases of infringement you would only be entitled to actual damages. To collect statutory damages, which usually are considerably more money, you have to have registered your images with the U.S. government's Copyright Office.

K: And to do this you fill out a form and include a copy of the picture. How many pictures can you register at one time?

W: If they are unpublished, there is no limit to the number of images you can register at one time. For published images, it has to be within a calendar year. (The forms are available from http://www.copyright.gov/forms.) I recommend registering them digitally, in CD or DVD format, and each photograph should be JPEGs and sized around 100 x 100 pixels.

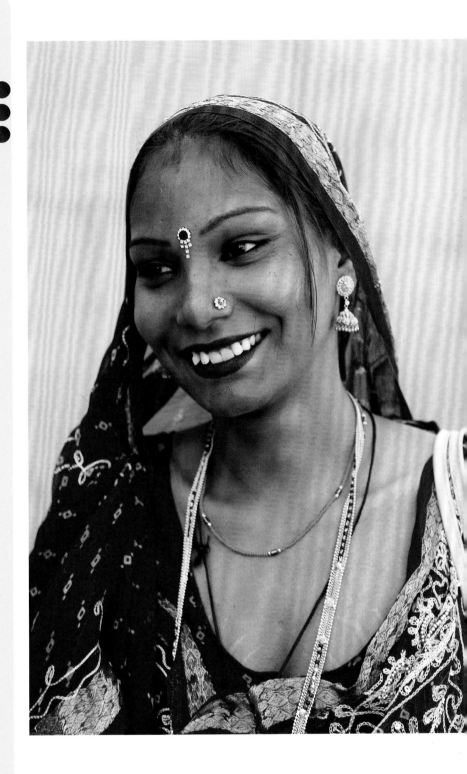

Photographing People: The Business

The Tipping Point

For anyone who travels and photographs people, it's an all-too-familiar scenario: you're walking down a street in a far off destination and you spot an interesting-looking local wearing the traditional clothing of the region—a wonderful potential portrait subject. You approach the person, start a conversation, and you are sized up immediately: your clothes, equipment, or lack of the language. Suddenly the shoe is on the other foot and the hunter becomes the hunted. Your subject's hand shoots out and you know, even before you hear the words "Baksheesh," "Propina," or "One Dollah," that you've reached "The Tipping Point."

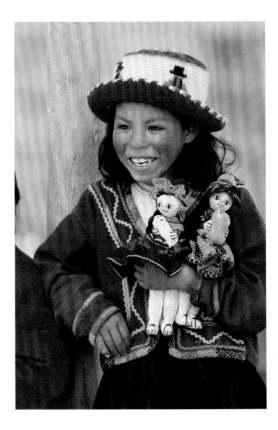

The question of whether or not to pay for pictures when photographing abroad is one that has haunted traveling shooters for a long time. As mass tourism has grown into a mega industry, and world economics creates a growing gulf between the very rich (that's us, believe or not) and the very poor, it's an issue that you'll have to deal with more and more in the coming years.

In an ideal world, the interaction between a travel photographer and his or her subject would be strictly a cultural meeting of the minds, a pleasant exchange of time, conversation, and maybe a print at some future date, where both parties feel as though they've gained something from the encounter. But when one of those parties is carrying a piece of gear that could easily cost more than the other party makes in two or three years of hard labor, you're not in an ideal world, and new paradigms evolve.

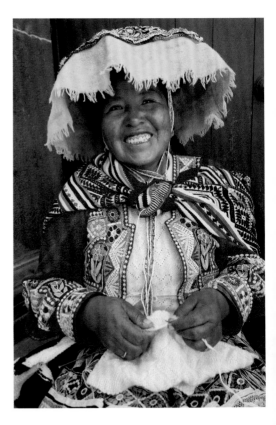

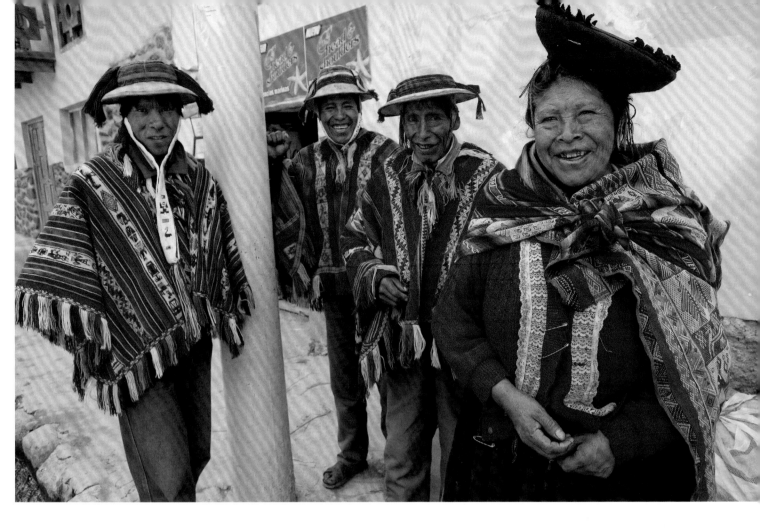

It's important to mention that, although the practice of local folks asking for tips in exchange for being photographed is widespread throughout the world, it isn't the custom everywhere. And if it isn't the custom where you're traveling, then don't start it! Often, a well-meaning visitor wants to help out by handing out a few coins, but it can snowball into a juggernaut of panhandling and begging that doesn't help anyone.

Similarly, in some cultures, it's an insult to offer a tip. Many of these cultures can be just as poor as one where tipping for pictures is widespread. Where societal norms preclude the idea of tipping, going around willy-nilly offering money for pictures will lead to a cultural impasse, rather than a cultural

encounter. Careful research into the destination you're visiting always pays off, both in better pictures and better understanding.

But in many places, the tipping precedent is set, so what's a well-meaning traveling photographer to do? A lot of advice I've read simply says, "No tipping for pictures." It's a noble but naive stance, and in many places I've been that would also result in "no people pictures" whatsoever. So, here are a couple of real-world pieces of advice to help you get past the tipping point.

International Commerce: In my travels, I've found that many of the most interesting-looking people are in the markets, shops, and stalls that line the streets of developing countries. One way to work around the tip is to buy small items from these vendors, and then ask for permission to make a picture. Even if you don't need the fruit, vegetables,

candy, or trinkets that they may be selling, your purchase has resulted in a net gain for your subject. In many places, that's all it takes to gain his or her permission for a couple of quick snaps.

With your purchase in hand, especially if it's food, you can often use that as a small gift for, say, the mother and child sitting on the next corner who may be selling pencils or flowers or something to make money for their next meal. You're redistributing goods and your subjects are receiving some material benefit from their encounter with you besides a literal "pay to play" exchange of money.

Another indirect way for your subjects to gain materially from your encounter is to give them a print. Unfortunately, so many photographers have promised prints to people then not delivered, that unless it's an instant exchange, your pledge to send a print doesn't

carry much weight. Until the digital revolution virtually killed the market for instant picture cameras like those made by Polaroid, pros got around this by carrying one of these to give away instant prints to portrait subjects.

Polaroids are phenomenal ice breakers (even in non-tipping societies), and handing a few out has resulted in a number of great pictures for me, not to mention a few lunch and dinner invitations from subjects as well! I once even got invited to a wedding in Portugal on the strength of a Polaroid given to an interesting-looking woman in traditional dress I photographed on the street in the Algarve (needless to say, I accepted!).

Alas, instant picture cameras are becoming a rarity. However, the good news is that there are still some available. My favorite Polaroid model was the Mio— compact, easy to carry, and made wallet sized pictures. It turns out that this model camera was actually made for Polaroid by Fuji and called the Instax Mini. Fuji still makes this camera and the film for the international market, and I order my replacement film from a camera store in Toronto. It's a bit of a hassle, but the instant picture is such a wonderful tool for breaking the ice and getting people pictures overseas that I gladly put up with the inconvenience of tracking down and ordering the film.

Grace and Discretion: I'm not a global economist, but the evidence I've seen in the last 25 years of travel is that the gap between the rich and poor nations is getting larger, and that the desperation of the poor in the countries often visited by tourists can be overwhelming. That desperation can often translate into aggressive behavior towards visitors, especially visitors with cameras.

If you find yourself in a situation like this, the key is to retain your cool and take the larger view. Although you may have scrimped and saved and worked tons of over-time to save up for this trip, in the eyes of the locals, you are still unspeakably rich. You'd like to take their picture and they know it, and it doesn't take a Harvard MBA to see the potential for making money here, even if the only thing you have of value to the potential customer is your image (ask any supermodel how this works!).

The key is to be discreet, selective, and polite. I've seen inexperienced travelers get so over-whelmed and annoyed that they literally throw money at folks, grabbing their shots while in retreat. Just because there may be a quid pro quo of money for pictures, that doesn't mean it can't still be a civilized and fun exchange. Maintain your sense of humor, try to charm and relax your subject, and keep a positive tone to the whole exchange.

If you find yourself being mobbed, just walk away until you can work with only one or two people. If you're doing the instant pic-ture thing, be especially discreet; word of free pictures travels fast and you can easily find yourself facing an entire village, each person wanting a Polaroid. That's why I avoid pulling out the instant picture camera unless there are only one or two people around, and not large groups.

If the exchange between you and your subject is still pleasant, you'll get better pictures and the whole experience will be positive. In some places, especially where the locals' colorful outfits and traditional clothing is particularly photogenic, there are long-standing traditions of tips for pictures. I recently visited the Sacred Valley of the Incas in Peru, where the indigenous people still wear beautifully colorful serapes and unusual hats. On my arrival in Cusco, the tour guide on the airport shuttle bus explained that the people were happy to pose for photographs, but expected a tip (or "propina" as they say in Spanish) of one sole (about $.30).

It was actually a kind of liberating experience to know a) that a tip was expected, and b) what the going rate was. I got a roll of coins before hitting a colorful market place

and had a wonderful time with people, getting good pictures and having fun with my subjects and we all came away with good feelings about the encounter.

With both mass tourism and global poverty on the increase, it's likely that we traveling photographers will be faced with more and more "pay to play" photo opportunities. True, it's not an ideal situation. But until conditions for everyone in the world are as ideal as they are for us, the best we can do is to remember the basic rules for all good travelers: be polite, sensitive, and nonjudgmental, and leave behind only good will (and maybe a couple of instant pictures).

archiving & sharing

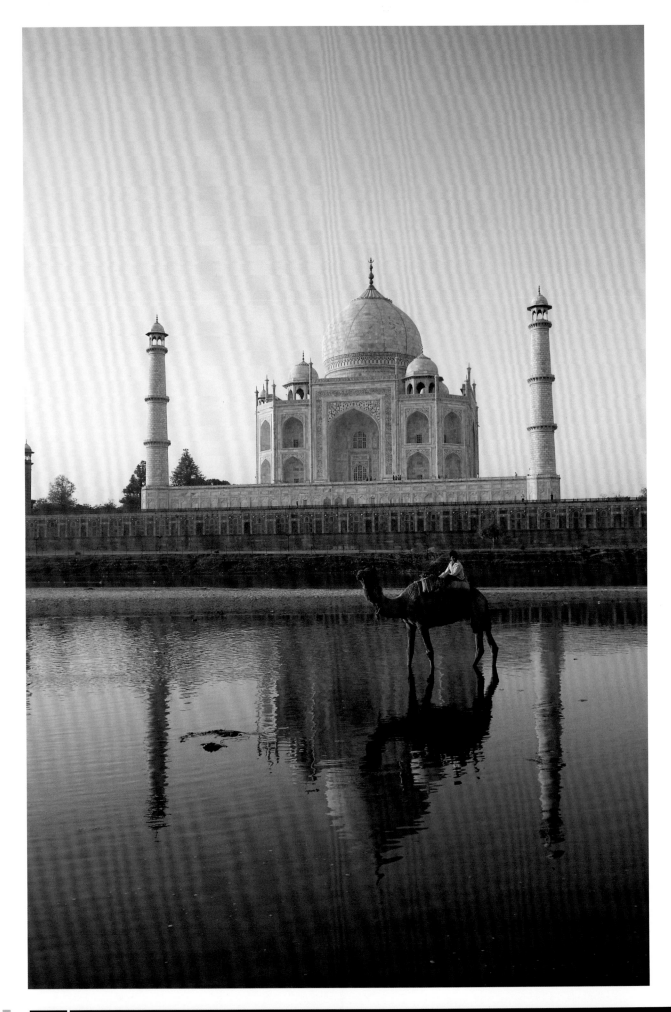

Coming Home: Archiving and Sharing Your Photographs

Digital Freedom, Digital Responsibility

Whether you've been out for a day's shoot in the neighborhood or on a three-week trip to Africa, the end of the trip doesn't mean the end of your work as a digital photographer. In many ways, your work is just beginning! This is very different from the film era—you just sent your rolls of film to the lab and waited anxiously for those little slides and prints to come back. When they did, you sorted them, maybe got a few printed, or if you were a professional, added captions to the slide mounts and sent them off to a magazine or stock agency.

That was then, and this is now!

Now you are the processing lab, you are the print maker, you (and your website) are the method of syndication, and you and your on-demand printer can also be the book publisher—it's all about you! It is a wonderful freedom, allowing for unprecedented control over your photographs and how they are used. But with any new freedom comes new responsibility, and unless you follow through with the whole process of a digital workflow after the shoot, your masterpieces will languish on hard drives or DVDs in a drawer somewhere— the digital equivalent of shoe boxes full of negatives or slides that never were sorted and hardly saw the light of day!

For me, all the new venues for sharing digital photography—web galleries, blogs, multimedia slideshows, print-on-demand books—are among the most exciting aspects of the technology. Add to this the convenience of making your own prints with an ink jet printer, and you have a myriad of outlets to share your work with the world. (For a complete rundown on the art of digital printing, please check out this excellent book, *The New EPSON Complete Guide to Digital Printing*, by my friend and colleague, Rob Sheppard.)

Self-Publishing

I started out as a newspaper photojournalist on a small paper in New Jersey, and have spent most of the rest of my career as a freelance magazine shooter. The only outlets I've had over the years to share my photo stories have been in the pages of magazines or books—both very competitive, with very tight spaces, usually edited by someone else.

This has been frustrating for a lot of career photographers over the years—just getting the space to show their work, and once getting the space, it's someone else who is picking and laying out the work. I remember a night of hanging out after a dinner with some colleagues, freelance magazine photographers, when a "what would you do if you won the lottery" discussion started. There was a lot of talk of fancy cars, boats, second and third homes—most of the usual stuff. But when it came to me, the thing I most wanted was to go back through all the stories I'd shot over the years to republish them. Only this time, I select the pictures and choose the layouts! That got a round of laughs from my colleagues at first, but in the end, almost everyone agreed they might do the same thing . . . after they got their boats, cars, and villas!

The other side of the self-publishing coin to photo sharing sites, do-it-yourself web galleries, photography forums, and chat groups is that maybe, just maybe, editors do serve a purpose! There is a lot—and I mean a lot—of plain, boring, and bad work tying up tons of Internet bandwidth. As a digital photographer, it is vitally important to remember the value of editing. Not everything you shoot must be shared with the world. It's the old showbiz saying: "Leave 'em wanting more." It's a lesson many of digital photographers would do well to learn!

Well, here we are in the digital age where my fantasy can become a reality, and I don't even need to buy a lottery ticket. Digital technology has allowed us to share our work with the world, without the need of a publisher. It's an amazing—and undervalued—byproduct of digital photography.

The Importance of a Color Managed Workflow

Once you start sharing your photos with the world, whether it's an ink jet print, a print-on-demand photo book, or a simple web gallery, you will want to take the necessary steps to ensure that the way the photo looks on your computer screen is the way it will look on other computer screens, in prints, or whatever the final output will be.

This process of standardizing the way the color in an image looks—from device to device and output type to output type—is called color management. There are reams of instructions and workshops, as well as numerous mystiques, surrounding this topic, but it all revolves around one thing: profiling your own monitor. When your monitor is profiled, the colors on it will look the same on it as it does to another profiled device (a printer, another computer screen, a photo lab, etc.).

Profiling your monitor has become fairly simple. All you need is a colorimeter—a device that measures the output of your monitor—and an accompanying software program that interprets the data from the colorimeter and establishes a profile. Not surprisingly, these two things are usually sold as a kit.

Two inexpensive and easy-to-use profiling kits are the Pantone Huey Colorimeter Monitor Profile System and the GretagMacbeth Eye-One Display Two. The Pantone product is relatively inexpensive, retailing for less than $100 and possessing a very rare feature that changes the monitor profile according to the ambient light in the room. The GretagMacbeth system, which is what I am using currently, sells for about $250 and is highly regarded by color management mavens.

The included software leads you through simple step-by-step instructions to create a profile for your monitor. LCD monitors are very stable once profiled and can probably go a few months between profiling sessions. Older CRT monitors should be re-profiled every few weeks.

The Final Edit

Assuming you've been able to do some daily workflow in the field (see page 39), what should be left on your hard drives is a loosely edited group of images—RAW or JPEG files, depending on how you shoot—that are already renamed, numbered, and captioned. Remember, I didn't want to make really critical editing decisions sitting bleary-eyed in front of a little 13" laptop screen late at night in my hotel room. I start that process when I return home—I sit down in front of my lovely twin pair of 24" Cinema Displays and do a tighter edit.

Again, the workflow that follows is just one way of doing things. It's a little system I've worked out and it seems to work fine for my needs. If you've already developed a workflow that is comfortable for you, by all means continue to use it. But if you're floundering for a workflow, you might find some of the following to be helpful. There is no one right way to do it, and with the constant upgrades and entire new generations of software programs that are introduced every other month, it is likely that my workflow may have already been modified by the time you read this.

Once I find a system that works for me, I try not to be seduced by the constant siren call of new programs and workflows. Not that I don't want to take advantage of the latest digital technology, but things change so quickly these days—it's easy to find yourself caught up in a permanent cycle of upgrading, becoming a slave to the slippery slope of a perpetual learning curve. So, when it comes to software, I like to spend some time enjoying the productivity that occurs when you hang out for a while on the plateau of competence (as opposed to struggling up or sliding back down the learning curve)!

Using my favorite browser, Photo Mechanic, I review the loose edit I brought back from the field and perform a more critical edit on the larger screens. Now I can scrutinize each image in detail by examining frames at 100%, seeing the content of each frame much more clearly on the large screen.

This is the point where probably half of the photos I brought home are also tossed into the trash. It's often a painful process, but I try to be very hard on myself. I often call upon my wife Peggy, who has been running my stock photo library for 25 years, to go over the edit again, and she is very tough. The ideal result is a tightly edited folder or two of strong images, already captioned and renamed. Then we apply some keywords to those remaining frames and get ready for the next step.

Post Processing

As I mentioned in the opening of this book, I am not here to teach you about Photoshop. I do very little Photoshop work to my pictures, and there are a host of other books that will help you in this regard. What follows addresses some aspects of Photoshop, but I only touch on these techniques.

If you only shoot JPEG image files, at this point you can simply back up your work onto DVDs or hard drives and go catch a movie or play a round of golf. But if you shoot RAW, this is the time you will pay the piper for the added measures of control and flexibility that RAW files offer. Like almost everything else in photography, it's a trade

off. Yes, you get all that after-the-fact control, but now you have to exercise that control to make the RAW file into something that can be printed, posted, and used. (*RAW Pipeline* by Ted Dillard is an excellent source for almost any question you may have about processing RAW images and, more importantly, streamlining a RAW image workflow.)

After creating my tightly edited folder of RAW files with Photo Mechanic, I drop that folder into another browser, Adobe Bridge. Bridge does almost everything that Photo Mechanic does, only slower and with a less friendly user interface (again, in my opinion). But it does one thing that Photo Mechanic doesn't—it provides direct access to the Adobe Camera RAW processing window, removing that extra step of opening them separately in Camera RAW.

My plan is this: go through the folder and optimize the images. I work on the exposure, contrast, white balance, saturation, and perhaps noise reduction to make the somewhat

flat and dull RAW files—they have a lot of information but appear pretty dull in their native state—look like my favorite film types (the punchy, saturated Fujichrome Velvia was my standard for landscape work and the more natural-looking Provia was my choice for people shots).

One thing I don't do at this point is open these files and convert them into JPEGs or TIFFs. Bridge offers tools that allow me to make several changes on one image file, save that set of changes as instructions, and apply them to other images. (Click "Done" rather than "Open" to save the instruction set; "Open" simply opens the adjusted file in Photoshop, which is not what I am going for right now.) For example, I adjust an image and click "Done" to save the adjustments as a set of instructions. Then if the next four, five, or more frames were shot in the same lighting conditions, I simply select them, and tell Bridge to "Apply Camera RAW settings" from the previous frame. This is all happening in Bridge; Photoshop is still not involved in any way.

Using this method—opening the first picture in a series with the Camera RAW converter in Bridge, making my adjustments, saving them, and applying the adjustments to other frames shot in the same conditions—I eventually work my way through the whole folder, optimizing the RAW files but never opening them.

Now I have my edited folder of RAW files, all with the instruction set for their interpretation into JPEG or TIFF attached to them in an .XMP sidecar file that stays with the RAW file. But the RAW file itself is never altered. The sidecar simply contains the instructions for how I'd like to process that individual RAW file.

At this point, I open Photoshop and go to File>Scripts>Image Processor. A window opens, asking me what folder I'd like the Image Processor to work on, and what type of images I'd like to process into: JPEGs, TIFFs, or PSDs (the native file format in Photoshop). I can select any or all three. I usually go for a large JPEG. After I select the folder, select the type of file I'd like, and choose where I'd like the new folder of JPEGs to go, I simply hit the "Run" button and voila! Photoshop will go through the entire folder of RAW files, applying the changes I specified and making JPEGs.

Depending on how many images I have in the folder, this can take from a few minutes up to an hour or so, during which time I go off and do other things. When I come back, there I have my captioned, keyworded, optimized JPEGs ready to be backed up and utilized.

Learning Photoshop and Other Programs

If you are like me, learning the ins and outs of complicated imaging programs like Photoshop is a little tough from the pages of a book. Ideally, I've done best when I'm working one-on-one with an expert sitting right next to me at my computer.

Unfortunately, it's not always practical, or affordable, to have an on-call Photoshop guru at your disposal. But you can do the next best thing, and that is to have that expert on a DVD, walking you step-by-step through various methods and explaining as he or she goes along.

There are a lot of experts out there, but my favorite is undoubtedly Julianne Kost, who actually works for Adobe in their "Evangelist" program. Personable, talented, and completely at ease in front of the camera, Julianne takes you step by step through the intricacies of the program in a series of DVDs done for an outfit called Software Cinema (www.software-cinema.com). Before I got my twin LCD screens, I would set up my laptop next to my main screen and watch Julianne on the laptop while I worked on an image on my main screen. It was a great way to learn, and being able to pause and rewind to get a second—or third—explanation of a particularly tricky point, is invaluable.

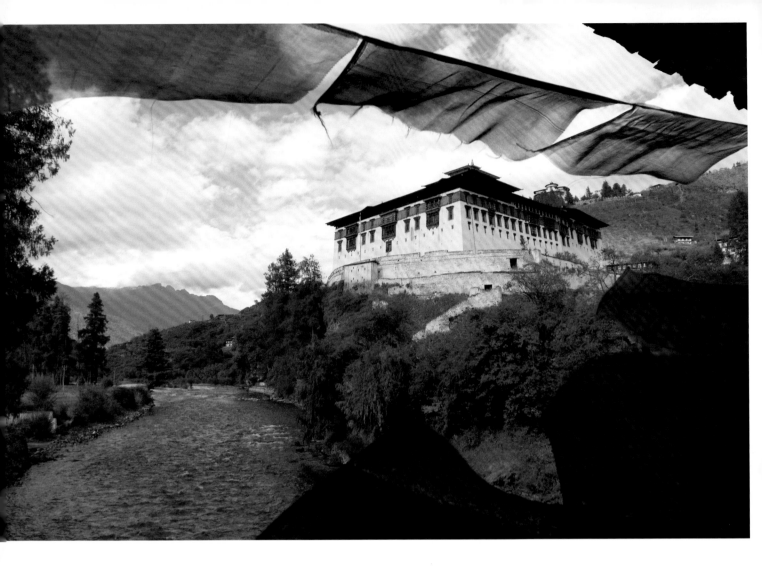

Backing Up at Home

Just as we backed onto the small, bus-driven hard drives in the field, we have to do more or less the same thing at home when creating the archive of our images. Using small 80 – 100GB bus driven hard drives for your archive isn't such a great idea—they're just too small.

The methods of backing up your digital archive are numerous (what isn't, in the world of digital imaging) and as I've mentioned, this book is not designed to explore them all in detail, but again, hard drives are a good choice.

It pays at this point to reiterate a few truths about digital storage. All hard drives will fail eventually. CDs and DVDs are not proving to be as good an archival choice as they were once believed to be. In order to make sure you'll have access to your "digital assets" for years to come, you need to have some kind of redundancy built into your backup system. One copy of anything is asking for trouble.

In my home office, I have two computer workstations: a pair of Macs. Connected to each of those computers, via Firewire cords, are two 2TB OtherWorld Computing hard drives. (That's TBs (terabytes), not GBs (gigabytes)—a terabyte is 1000GBs, so that's a fair amount of storage.)

On each drive, I have the same archives—all my RAW files, their corresponding high resolution JPEGs, and all the high resolution TIFFs I've made from scanning my film collection. So my archive is backed up four times. I try to run only one drive at a time. The computers and the drives are plugged into a UPC (uninterruptible power supply), which is essentially a battery backup. In the event of a power failure (which are alarmingly frequent in my little corner of eastern Pennsylvania), the batteries provide enough power for the computer and the drives to go through the prescribed shutdown sequence—always helpful when you need to preserve your data.

When I add new files to the archive, I use a small hard drive to move the files from one workstation to another and copy them onto all four drives. (It's a method that digerati wags call "sneakernet.") One day I hope to network all the drives and computers, and maybe even run a server. But I don't need constant, 24/7 access to the data so it's not yet a pressing need.

In addition, I try to make two DVD copies of my edited RAW files that I keep in notebooks. One notebook and one 2TB drive are usually stored in my parents' house next door, just in case.

All this redundancy may seem, well, too redundant. After all, my same office is filled with file cabinets containing 140,000 slides, which are one-of-a-kind items. But short of a fire or flood, those slides will just stay there. Digital data is more ephemeral; I've already had drives fail and DVDs become mysteriously unreadable in the course of a couple of years.

Each photographer has to be comfortable with his or her own system of backup. Even with my current setup, I'm still not entirely at ease. After all, this is my life's work and the way I make my living. As far as I'm concerned, when it comes to backing up a digital archive, you can never be too careful!

Sharing Your Work Through Multimedia Slideshows

For readers of a certain age, the phrase "slideshow" will evoke memories of dark rooms and endless overexposed slides of Uncle Joe's vacation presented in the clunky cadence of slides dropping in and out of a carousel tray. In short, "slideshow" became shorthand for "boring."

Now, with a few clicks of the mouse, you can create professional-looking slideshows with a myriad of transitions (dissolves are just the beginning), and an ability to make movie-like moves over a still frame (the so-called "Ken Burns Effect," named after the documentary filmmaker who made the practice of panning a video camera over a still frame a big part of his film, "The Civil War"), add one or more soundtracks, narration—your imagination is the only limit.

When you begin to work with slideshows, it's best to keep it simple. Several programs, including Apple's venerable iPhoto, allow you to simply select a folder of pictures, select a soundtrack from your iTunes library, and a transition style. The program either times the slides to match the length of the musical selection, or allows you to select the time you want each slide to stay on screen; the music repeats or stops early as needed.

I find 4 – 5 seconds is a good length of time to keep a slide up. As cool as the "Ken Burns Effect" is, I'm not fond of it because I'd like my photographs to appear on screen the way I framed them. In the simpler programs, this effect is applied randomly. In more sophisticated programs you can exercise more control of the Ken Burns panning effect; where it starts, where it stops, and how fast it moves.

Adding Music to Slideshows

Picking music for a slide program is almost as important as the pictures themselves. As long as you are producing these slideshows for friends and family only, you probably don't have to worry about copyright issues. But, if you are presenting the show in public, or being paid to present it, then you need to clear the rights with the creators of the music.

This may seem like an annoyance, but keep in mind that musicians don't enjoy having their work co-opted and used for free any more than photographers do. We expect people to honor our copyrights in terms of using our photographs, so the least we can do is show our musical brethren the same courtesy. Rights clearance can take on the aspects of detective casework, in part because there's no overarching clearinghouse for music rights. Corbis, (www.corbis.com) the big stock photo library, has a rights clearance division that can help track down the owners of rights for

you. Other companies, like www.clearance.com, can also assist you. Another avenue is to contact the individual artist, although this can be time consuming. If you do a lot of public presenting of your slideshows, you may want to consider royalty-free music. In this arrangement, you buy a CD of music that fits your needs, for say, anywhere from $50 – $250. With that purchase, you basically have the rights to use the music any way you'd like.

You are not going to get any Lennon/McCartney or James Taylor soundtracks in royalty-free music. Instead, what you get is a more generic soundtrack of background-type music, which is often preferable to a well-known song by a major artist—you want the audience to pay attention to your photographs, not necessarily the music.

Since most of my work is travel related, I use a lot of ethnic and world music in the backgrounds of my slideshows. I've worked rights clearances with individual artists, but the royalty-free music is much more economical. I can often get a CD full of different cultural themes for the price I would have to pay for one song from an individual artist for the presentation rights to use in a slideshow. Needless to say, I'm a big fan of royalty-free music for my slideshows.

Multimedia Storytelling

Slideshows can be more than just music and pictures. An emerging catchphrase in newspaper and magazine photography circles these days is "multimedia storytelling." In an effort to keep up with the great emphasis on video in our daily lives, many photojournalists have been carrying small digital sound recorders to record ambient sound, interviews, and narration to run along with their

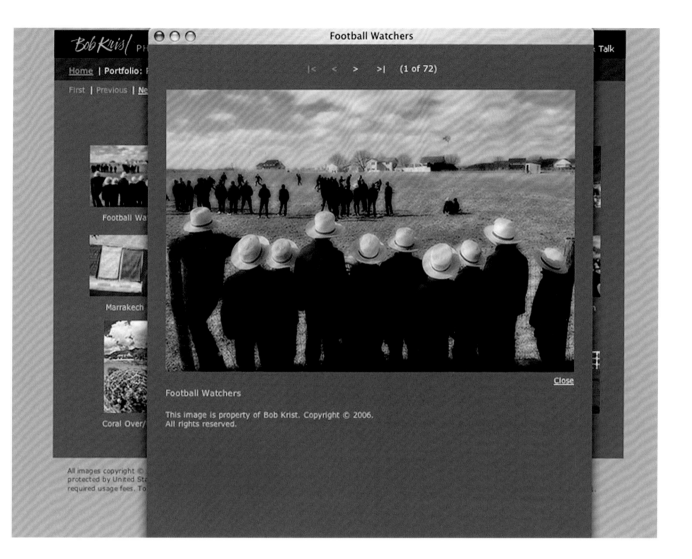

Close

slideshows. What exactly is ambient sound? It's the naturally occurring sounds that come from the place or the story you're shooting.

Let's say you're shooting around an old restored steam locomotive. Well, you'd be sure to record the characteristic "toot" of the train whistle, the "chug-chug" of the wheels as they begin to move, the conductor calling "All Aboard," and things of that nature. You might ask the engineer a couple of questions about his love of railroading while he's waiting in the station and record his answers. Soon, you have snippets of a soundtrack that can run, along with some music and maybe some narration of your own, under your slideshow.

This adds an exciting new dimension to storytelling, and it's one of the things about shooting digitally that has me the most excited. Of course, it calls for some added skills in the field and at the computer.

A small digital voice recorder is all you need to get started in this kind of work. I started with a small Olympus voice recorder, about the size of an iPod Nano, along with a small microphone. The whole outfit weighed less than 6 ounces and took up no room in my camera bag. The sound quality was decent for most applications (in windy conditions, it got a little dicey), but it was a serviceable for my entry into sound recording.

Now I work with a slightly larger, more sophisticated recorder, a Zoom H2 (www.zoom.com). This unit is about the size of a pack of cards, records to SD memory cards, and comes with four built-in microphones. It records a cleaner sound and—just like a camera—the more you use it, the better you know how to use it.

For mixing your sound clips, music, and narration into a soundtrack, you can use a program like Garageband, part of the iLife software suite, for Mac users, or Audacity (www.audacity.sourceforge.net)—a freeware and cross platform that can be used with PC or Mac.

Exporting Your Slideshow

If you are showing your slideshow live with your laptop, you can present it using the same software you used to create it. But if you're burning it to a CD or DVD to distribute, or you want to put it up on a website, you'll need to export the slideshow to a more universal format, such as Quicktime. Almost all computers (Mac or PC) support Quicktime, and it's a good format for this. Programs like iDVD (for Mac) or CD & DVD Pictureshow (for PC) will burn a DVD from your slideshow that is playable either in a computer or your TV's DVD player.

Another option is to export your finished slideshow as Flash (one of the favorite animation programs used by web designers), which can then be posted as a self playing slideshow on your website. The simplest way to do this is to use an ingenious program called Soundslides (www.soundslides.com, or the professional version, Soundslides Plus). This program takes your soundtrack and slides, allows you to work with transitions, titles, captions, etc., and

Sources for Royalty Free Music

• www.musicbakery.com

• www.uniquetracks.com

• www.partnersinrhyme.com

• www.royaltyfreemusic.com

Programs for Creating Slideshows

• Photos to Movie—www.lqgraphics.com (PC or Mac)

• iPhoto—www.apple.com (Mac)

• Keynote—www.apple.com (Mac)

• Proshow Gold—www.photodex.com (PC)

• CD & DVD Pictureshow—www.ulead.com (PC)

• Soundslides—www.soundslides.com (PC or Mac)

then outputs the whole thing as Flash. You don't need to know the first thing about Flash to use Soundslides, which is cross platform and was developed by a couple of photojournalism professors.

Once you get the multimedia bug, you'll find a lot of subject matter in the activities of families and friends, weddings, reunions, and vacation trips. It's a great way to involve other family members; kids in particular seem to love to record sound (the iPod generation). In my travels, my wife Peggy has become my sound technician, and it's fun to work as a team creating our little slideshows.

Print-On-Demand Books

In my 30 years as a professional photographer, nothing has given me more satisfaction than seeing my work published in a big, hardcover coffee table book. Indeed, having one or more coffee table books of your work is a milestone many professional photographers strive for their entire career. "A coffee table book," as one colleague wryly noted, "is like a seven pound business card. It gives you and your work weight."

One reason a coffee table book was so coveted by pros was because of the difficulty involved in having one published. Not many publishers did big photo books, and when they did, nobody made much money, further removing the incentive to publish. However, speaking from the experience of having eight such books published, I can say, without getting too preachy, that it is "easier for a camel to pass through the eye of the needle" than it

is to convince a publisher to do a photo coffee table book. For that reason, these books remained a brass ring that very few photographers were able to catch.

No one went into publishing photo coffee table books to get rich—it was more for the satisfaction of seeing (and holding) the beautiful presentation. Years ago, when I started playing with iPhoto, Apple's consumer-level photo program, and I saw an option to "Print a Book," I thought, "How good can this be?" On a lark, I grabbed a folder of photographs from an assignment I had just shot in the South Pacific, went through their very simple, user-friendly interface to lay out the work, and uploaded the book.

I didn't think much about it and was totally blown away when, a week later, my wife brought in the mail wanting to know which publisher had done the beautiful book with my South Pacific pictures! I was quite impressed with the print quality, the speed of turnaround, and how I, a self-admitted graphic design Neanderthal, was able to effortlessly put together a nice looking layout. Needless to say, I was hopelessly hooked.

Since the iPhoto breakthrough, countless print-on-demand services have emerged on the web, and I've tried most of them. Experiment with book providers to see which workflow and printing quality you like the best, because they all vary. Some providers require you upload your pictures to their site and then create the layout. Others allow you to make a book layout from pictures on your hard drive and then only upload the finished pages (usually in PDF form). I find the latter to be preferable, as it can take ages to upload 20 or more good-sized JPEGs, even with a high-speed connection.

On-demand printers differ slightly in the types and sizes of books they offer and prices are fairly resaonable. Some printers put a 100 page limit on books, though some can go up to 300 pages. This is to illustrate that, while it's relatively inexpensive to print one or two books as gifts and keepsakes, you won't be publishing thousands for bookstore consumption (unless you actually won a lottery and you're in desperate need of a big tax write-off!).

If you'd like other people to be able to order your book, pick a supplier that offers this option. Some print sites will allow anyone to order the book (with your approval), or may limit purchases to a list of names and contact info that you provide. You can set the selling price for the book, but since they're fairly expensive to print, there's not much of a margin for you if others order the book

(unless you set an unrealistically high price). On the other hand, there are no handling hassles for you if you choose this method.

No matter which supplier you chose, there are a few things you can do to make sure your first book is a success. For a book to hold together thematically, make sure your pictures tell a story. There is no law that says you can't do a book entirely of flower close-ups, or an entire book of horizontal landscapes. But pacing, variety of subject matter, different perspectives, and an editorial thread will help make your photo book much more of a page turner.

That means you have to "shoot for story" so remember to actively create a visual narrative of your trip, or the destination, in pictures. Shoot with a narrative thread and including wide overalls, medium views, and close-ups of storytelling details, rather than only going for the one killer shot. Work the situation from all angles with lots of variety in lens choice and point of view (hopefully you'll get more than one killer shot!).

Categories Help
Keep Your Story Straight

It is easy to lose sight of your photo "story" when on location and fall into shooting your favorite type of shots. I, for instance, tend to shoot landscapes and people a lot because those are my favorite subjects, and I am almost always light on architecture, shopping, and detail shots. A good layout for a book, magazine article, or slideshow needs to have a broad range of subjects and treatments to move things along.

To do this, many shooters keep a list of categories to remind them of what needs to be covered. For instance, for a travel piece, your category list for a shoot of a city might look something like this:

• Skylines

• Street scenes

• People (including local celebrities, characters, street performers)

• Recreation (weekend activities in parks, participatory sports)

• Culture (performing arts, museums, galleries)

• Historic monuments and buildings

• Shopping

• Hotels and dining

• Entertainment (nightlife, clubs, bars)

• Storytelling close-ups or detail shots (beer steins and pretzels in Munich, baguettes and wineglasses in Paris)

• Neighborhoods (ethnic or distinctive neighborhood scenes)

• Festivals, street fairs, parades

• Aerials

If you come home with several good shots in each of these categories, you'll have a nicely rounded city portrait that will look well designed and beautifully paced as a book or slideshow.

Of course, tailor this list to the subject. If it's a hiking story, for instance, you can replace skylines with landscapes and replace street scenes with hikers on the trail, or substitute tents and campfire scenes for hotels and dining out.

Visual Homework: Shooting for Story and Layout

While the art of a narrative photo essay is all but lost in contemporary travel magazines and books, there are still a few places you can explore to get an idea of what makes a strong picture story and how to create it. *National Geographic* still produces in-depth photo essays (as opposed to just a group of related pictures), as do the German magazines Geo and Merian (these are usually available at well-stocked magazine racks in large metropolitan areas).

For great examples of coffee table book layouts, you only have to look for the books of some of the photographers whose work you most admire. I look to the work of Franz Lanting, Chuck O'Rear, and Ian Lloyd. There is often a cinematic quality to their books, and they make good use of pacing with sweeping establishing shots, medium scenes, and extreme close-ups expertly placed throughout the layout.

When laying out your book, remember the "less is more" rule—resist the temptation to sprinkle page after page with multiple picture spreads. Some layout templates encourage the shotgun approach, but they are usually designated for scrapbooks or yearbooks. Fewer pictures displayed larger will always have more impact than a lot of small pictures on one page. Some templates won't allow the use of more than two pictures on a page. If you find yourself tempted to put dozens of pictures on a two page spread, you may be wise to pick one of the templates that won't let you!

As far as I've been able to determine, only a few layout templates, like Apple's Aperture, allow the printing of one picture across two pages (called a "double truck" in the business). Double trucks have great impact, and I miss them in these book layouts (possibly enough to spring for an entire software program just so I can do books with two page spreads.)

Pitfalls to Print on Demand

There are some limitations to these books you should be aware of. First and foremost, there is no proofing process. You can soft proof the templates on your own printer, but be aware that there will be some deviation in the color reproduction. I work in a color-managed environment, and so do most of the printers, but the holy grail of absolute color fidelity is still not a total reality.

Also, printing can be inconsistent. I sent one book off and when it came back I was so pleased with the results that I ordered a second one, but the printing on the second was not as crisp and colorful as the first—it wasn't bad, but it still wasn't the same. You'll also need to do a couple of books with a supplier to get an idea of how much to sharpen and saturate the pictures for best reproduction. It varies from company to company.

These are minor annoyances compared to the satisfaction of holding a collection of your best photos beautifully bound between hard covers. Just be careful—while creating these little masterpieces doesn't require a lottery win, it can be habit forming.

Photo Sharing Sites and Web Galleries

There are many other ways to get your work out there to share with others. Quite a few of the photo sharing sites that sprung up in the 1990s are still going strong. Many of them were first developed as a way to order prints from your digital images, but many have gone beyond merely being an online lab and blossomed into full blown worldwide online photo communities where thousands of pictures a minute are uploaded.

As with software, cameras, and computers, it's best to explore several of these online photo sharing sites to see which one feels right to you (see the sidebar "Photo Sharing Websites" for some of the many choices out there). Some charge a yearly fee to save you

Websites for Print-on-Demand Photo Books

• www.apple.com—Mac platform only. Both iPhoto and Aperture offer custom book printing options, with Aperture offering the most flexibility. You don't need to upload pictures with these services; only the final pages in PDF form are uploaded.

• www.sharedink.com—Dual platform for PC or Mac. One of the only services with a money back guarantee if you're not satisfied.

• www.blurb.com—Dual platform. Offers hardcover books with dust jackets, a relative rarity in print-on-demand.

• www.photoworks.com—Dual platform support

• www.shutterfly.com—Dual platform support

• www.picabo.com—PC platform only

• www.snapfish.com—PC platform only

• www.mypublisher.com—PC platform only. Offers a large 15" x 11.5" format book. Will print iBook layouts with a Mac plug, but the oversize template is PC only.

from having to deal with advertisements, while some are funded through selling ad space on the site. Some free services offer premium, subscription-based service with unlimited online storage for your photos. There are also sites designed to function as stock photo galleries where you can offer to sell your photographs.

What most of these sites do is create ways of posting galleries (inviting comments from either the public or a user-selected group of friends) and photo storage (another important way to back up your work offsite). The storage feature alone is a compelling enough reason to join one (or more) of these online photo communities.

Photo Sharing Websites

- www.flickr.com

- www.pbase.com

- www.smugmug.com

- www.digitalrailroad.com—stock enabled, fee based storage

- www.photoshelter.com—stock enabled, fee based storage

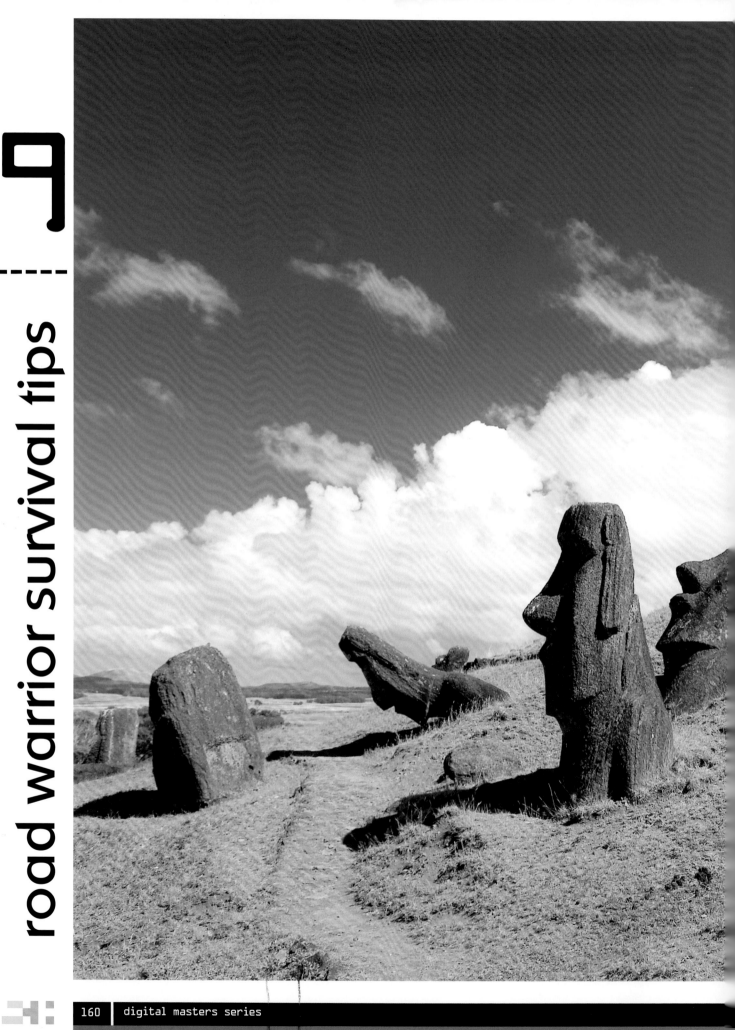

road warrior survival tips

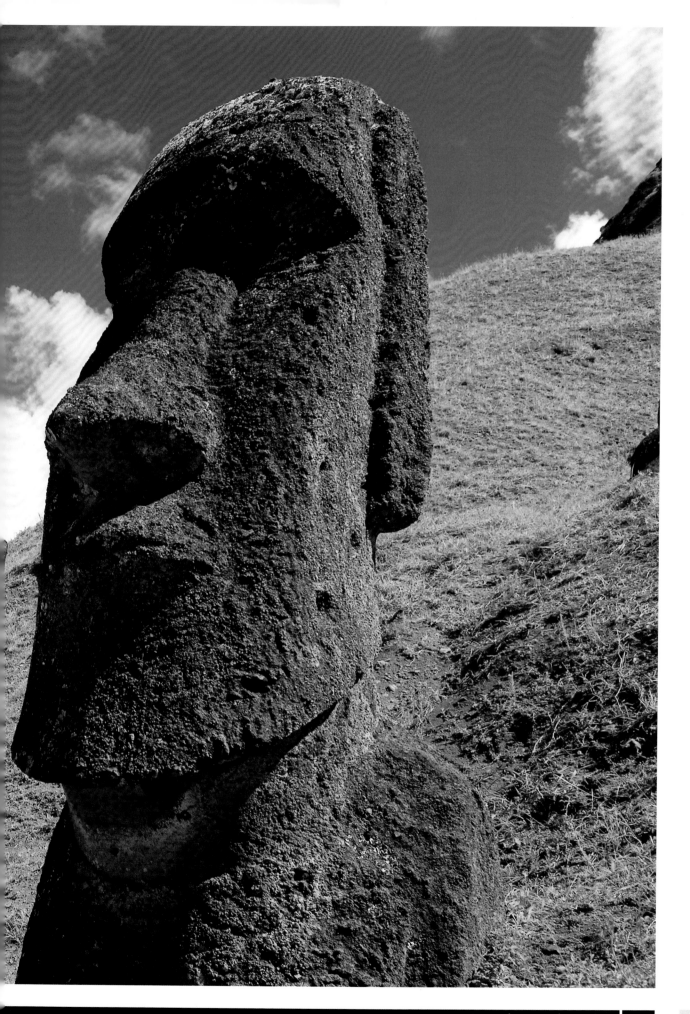

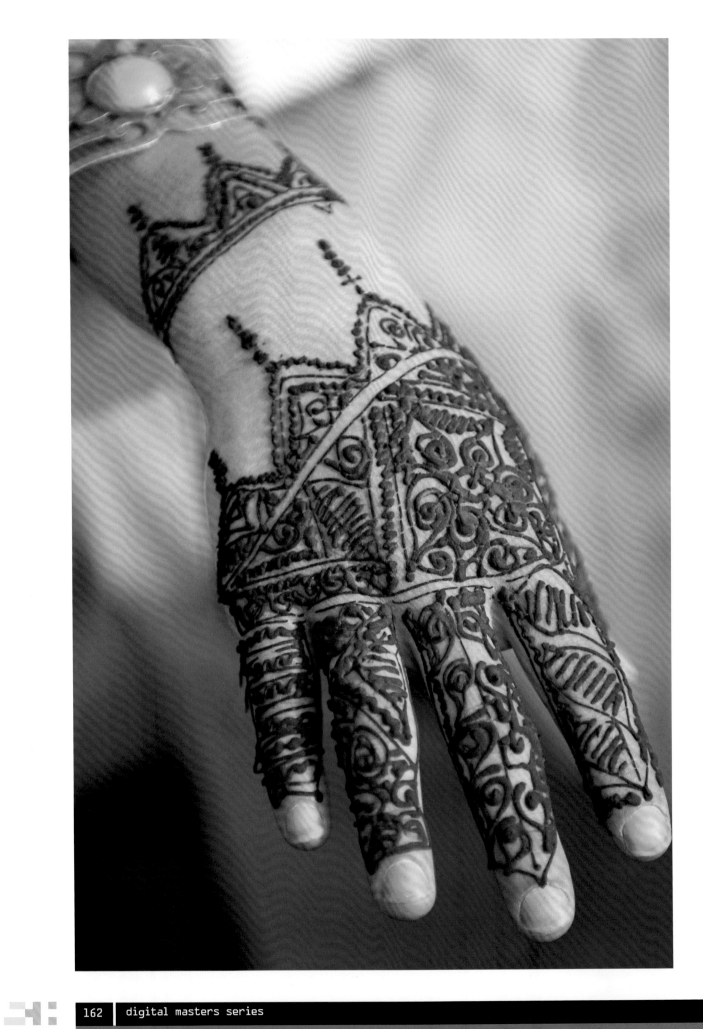

Road Warrior
Survival Tips

WHACK! The bear's huge paw connected squarely with my face. Even though I saw it coming, there was nothing I could do because my seatbelt was already fastened. Seatbelts in the wild? Not on your life—I was in a jet plane. But do they really let bears on board a jet? Well, once you let snakes on a plane, what do you expect?

Okay, okay: this was just a stuffed bear. But it was gigantic—at least four feet tall! And it was being lugged down the narrow aisle by a headphone-wearing, sleepy-eyed teenager, along with a full-sized pillow and a huge, overstuffed backpack bursting at the seams with dirty laundry. The stuffed Ursus managed to maul everyone sitting on the aisle between the plane's front entrance and its owner's assigned seat in a rear row.

A total ban on carry-on luggage doesn't seem to be too unreasonable when you consider the trials of air travel. But for those of us who need to travel with things more valuable and fragile than dirty sweat socks and oversized teddy bears, the prospect of such a ban is a nightmare waiting to come true.

Banning all carry-ons is an extreme and probably unwise policy from a business standpoint for the airlines, too. There is no telling what may happen if there is another scare, or worse, an actual incident involving weapons or explosives carried onto a commercial aircraft by passengers. A total ban certainly does eliminate the security problem, and it alleviates the annoyance of nonessential Pooh Bears and dirty laundry dragged on board purely to avoid the inconvenience of checking bags. But it's not an equitable and fair solution to the people who need to travel with valuable and delicate electronics, computers, and optics to pursue their professions.

The carry-on debacle is just one of the hurdles facing traveling photographers today. Lost or pilfered checked luggage, late flights, surly passengers, and indifferent airline personnel make air travel more of an "adventure" today than it's been since Orville and Wilbur's era. In truth, flying has been no fun since deregulation in the late 1970s, but it's been a downright ordeal since 9/11. Is there anything we peripatetic photographers can do to alleviate or prepare for worsening conditions?

There is no pat solution or easy workaround. There are only small measures we can take and compromises we can make to try to work around the sometimes Draconian rules that arise in times of heightened security and the accompanying chaos. The following are a few things I'm doing to deal with the current (and possibly future) hassles and are my suggestions to you in honing your inner road warrior.

Check your insurance: It's almost inevitable that in the future more of our gear will be going into the hold, so take some time to check the details of your homeowner or camera insurance. Explore the possibilities of extra insurance for checked baggage. Keep detailed lists of your gear and their corresponding serial numbers packed in checked bags.

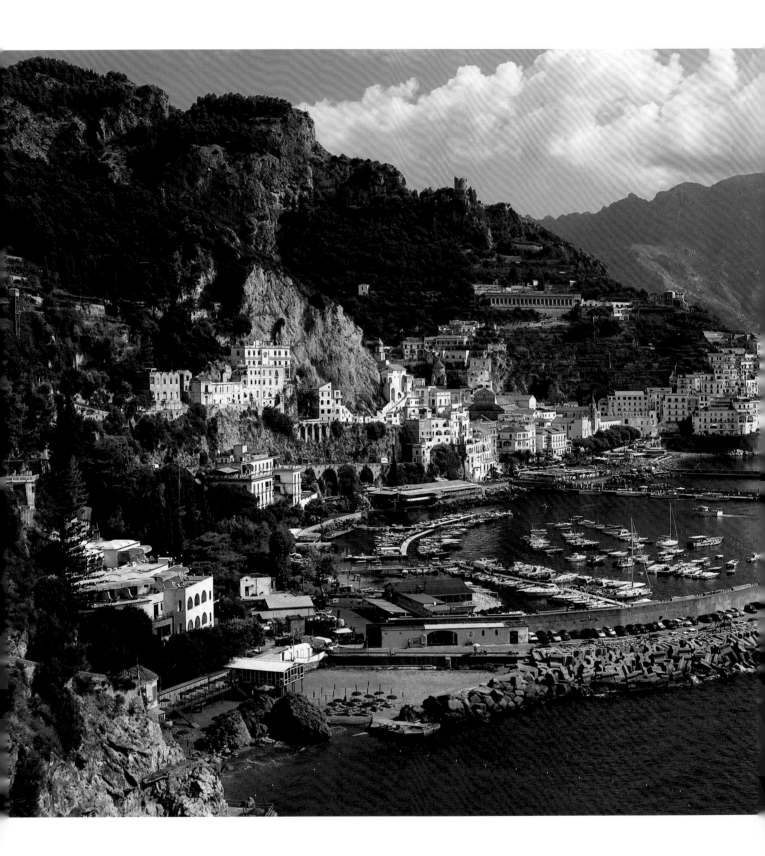

I recently read the fine print on an airline ticket that said that $2,600 per lost bag was the limit of their liability, but not a guaranteed remuneration figure. If you have paperwork to prove what you've lost, your claim will go faster and easier.

Use TSA-approved Travel Sentry luggage locks: If you haven't done so already, get the TSA-approved luggage locks for your checked bags. Granted, they're not even remotely tamperproof or heavy duty, but they are the only TSA-approved locks available, and are better than nothing at all.

I recently had gear stolen from bags locked with these locks in the San Juan, Puerto Rico airport. The locks were locked and intact when I retrieved the bag, so that means there are either larcenous TSA personnel working there, or an even more frightening prospect: there are other individuals who can also effortlessly open these locks and move around the airport's checked luggage system at will! While not perfect, at least these locks will prevent casual pilfering.

Camouflage and individualize your checked bags: We all love the protection that aluminum and molded plastic cases provide for our gear. Unfortunately, these cases tend to advertise, "Valuable stuff in here worth stealing!" I've taken to putting my Lightware, Pelican, and Stormcases inside other bags—like green canvas Army surplus duffle bags—to make them more innocuous-looking.

An acquaintance, who does a lot of dive travel and photography, actually spray painted his luggage and gear bags with big, obnoxious red polka dots. His reasoning was that, if lost, they would be easier to identify and track down, and if stolen, they'd be much harder to inconspicuously slip out of an airport. This sounds logical to me (if you can live with the ignominy of huge polka-dotted luggage).

My own, more modest solution is to attach bright, fluorescent-colored wraparound handles to my bags, making them easy to spot across the luggage carousel. In addition to individualizing and camouflaging my bags, I also put large stickers inside with all my contact information and big red letters reading, "REWARD IF FOUND." My thinking is that anyone who steals my stuff will eventually have to resell it, and I'd rather buy it back myself than have it go to some unscrupulous pawnshop or elsewhere.

Toughen up: Soft-sided luggage and the Cordura-and-plastic shell cases have always been vulnerable to unscrupulous handlers with razors or box cutters. Even if the zippers are locked, you can slice into these bags. An Australian company named PacSafe (www.pac-safe.com) has developed a series of flexible steal mesh covers for backpacks and duffles, as well as a full line of backpacks, duffles, shoulder, and waist bags with the mesh built into the fabric that prevents "slashers" from slicing open your gear in transit. They also feature a metal locking cord that allows you to padlock the bag to a radiator or some other immoveable object in your hotel room. This is about as secure as you can get without going to extraordinary measures.

Travel lighter: Do you really need that auxiliary battery pack that adds height and weight to the camera body in exchange for 6 fps (frames per second) performance instead of 4 fps? How about that 300mm f/2.8? Could you get by with a much smaller, lighter 300mm f/4? These are the hard questions we need to ask ourselves in light of 21st century air travel.

Early in my freelance magazine career, I shot a story about an expert backpacker who was fanatical about weight conservation with his gear. He actually cut the handle down on his toothbrush and shaved some millimeters off his hiking shoes' soles just to save a couple ounces of weight. His reasoning, quite correctly, was that every little bit helps. I've taken his advice to heart my whole career, especially in recent days.

Currently, I'm experimenting with a mid-level Nikon D-SLR camera. It's smaller, lighter, and cheaper than the top-of-the-line pro D-SLRs and produces a 10MP image as opposed to 12MP. It doesn't have some of the bells, whistles, and ruggedness of the larger camera, but in some cases, the trade offs are worth it to me—and my spine—in terms of saved size, weight, and packing space.

Similarly, I'm experimenting with carrying smaller lenses. The APS-sized sensor in my camera means that most of my lenses have a 1.5x image magnification effect. I've been frustrated by smaller, slower wide range zooms, but I am reexamining lenses like the 18-200mm VR Nikon, as well as smaller, faster lenses with less range, such as the 50-150mm f/2.8 Sigma. It gives me the same basic coverage as a 70-220mm zoom on a 35mm body, but is about half the size and weight of my current 70-200 mm f/2.8 VR zoom.

Will these equipment compromises totally replace my larger workhorse gear? Probably not. But if they shave off crucial weight in carry-on situations where an extra ounce or two might mean the difference between carrying gear onboard or sending it down to the hold (many international airlines have strict carry-on weight requirments), I'm game to try them.

Beyond the Airport

In these days of terrorism worries, we are often so fixated on what happens at the airport when it comes to security screenings, carry-on rules, and the like that we forget that there are other, more traditional security pitfalls that await us at some destinations. At this point, petty theft and crime affect more travelers than terrorism. While totally fixating on what bad things might happen can ruin a vacation, so can falling prey to scams, pickpockets, and thieves that are common the world over.

Photographers are especially vulnerable because we often carry equipment on our shoulder, and display for the whole world to see what might be worth three or four years of the typical local salary. It's a strong temptation to say the least, even in developed economies.

You can greatly increase your chances of a trouble-free trip if you follow a few of these guidelines.

Foil pickpockets: There are countless aids available to help you deter pickpockets. Put your wallet, passport, and tickets in a pouch that hooks around your belt and rides inside your trousers or skirt. Use a money belt for extra cash. Avoid waist packs, as they advertise where all your valuables are. They are so uncomfortable that many people take them off when they sit down at restaurants, and often leave them behind. Many travel gear catalogues—like Magellan's and TravelSmith—offer shirts, blouses, jackets, skirts, and pants with zipper pockets for your valuables. These are extremely useful.

Develop a sense of the street: It's easy for us to become so wrapped up in our picture-taking that we lose track of what's going on around us, what scoundrel might be sizing us up, or what truck, bus, or oxcart is barreling down on us. Working with a camera to our eye that almost totally blocks out peripheral vision is no help, either.

My early years as a newspaper photojournalist on the streets of Jersey City, Hoboken, and Newark helped me to develop a sense of what was going on outside my viewfinder as well as in the frame. You need this "third eye" awareness in cities and out in the wilderness too. You don't constantly have to be looking over your shoulder, but it helps to practice a dual awareness of the world inside and outside your viewfinder.

Copy or scan your documents: Make copies or scans of the ID page of your passport and your airline tickets. Stow one set in your carry-on bag (or in a bag where you aren't already carrying the originals). Keep another set at home with someone who can fax them to you should the originals be lost or stolen. You can also keep copies on a secure FTP site where you can access and download them should the need arise. It is infinitely easier to replace lost tickets and passports if you have these copies with you. It can literally save you days of trouble.

If you do lose your passport, or need to apply for visas on the fly, you'll save even more time and money by already having passport-sized photos of yourself. I carry four extras and they've come in handy on several occasions, including a situation where I had to get permits to shoot in historical areas in Mexico and provide a pass with photo I.D. Having the pictures ready saved me at least half a day or more.

Once, on a trip to India, I was working with my airline tickets in my shirt pocket. These were old style paper tickets, which were printed with red carbon paper on the back. I got caught in a monsoon downpour, and I scrambled to protect and pack up my gear, which I did fast enough. But my shirt was soaked and the airline tickets became lumps of unreadable red paper! Fortunately, I had copies of the tickets in my suitcase, which helped smooth the replacement process and didn't take any time away from the assignment.

Take several copies of an equipment list with serial numbers: Chances are, unless you are carrying several cases of professional-looking equipment, you will have no problem entering a country with your gear. However, in some places—like developing nations and even tourist destinations like Bermuda and Jamaica—customs officials are wary of people bringing in even a modest amount of equipment. (They are concerned that you will try to sell it.) If customs officials stop you when entering a country, you can often defuse the tension by presenting a list of your equipment with serial numbers and offering to have your gear inspected against this list when you leave.

If you are working on a professional assignment, the local tourist board can assist you if you fax this list to them before your arrival. To be completely safe, you should register your gear with US Customs before you go so you have no trouble getting back into the country. Ask for a Form 4457. Frankly, I don't do this anymore, since I almost always customize my choice of equipment to each assignment, and I don't want to take the time to register a new list every time I leave the country. I have never been hassled about bringing my stuff back into this country.

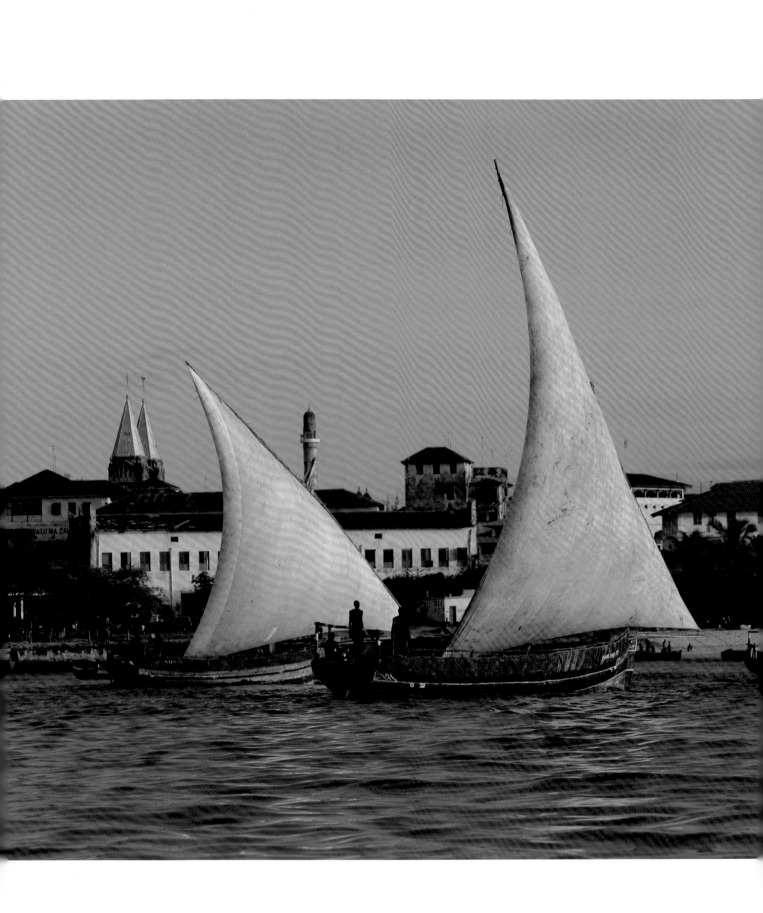

Hotels

By and large, hotels are safe places, but not totally secure. Recently I pulled up to a small, but very nice hotel in the capital city of a developing country after arriving late one night. After unloading my bags, the taxi driver pulled away and a "bellman" ran up and wanted to help me. I could have used the help, but something didn't feel right, so I shooed him off strongly and gathered my bags quickly. What was it that set off alarm bells in my head? Probably the fact that, in all my years of travel, I had never seen a bellman working together with a six-foot-two transvestite in a miniskirt!

Once I got my gear into the lobby, the night desk attendant warned me about the guy—he and his "partner" tended to prey on late arriving guests. It's a pretty good scam, and I might have fallen for it if it weren't for his flashy accomplice. Nevertheless, it points out something extremely important: the transition points—getting in and out of taxis, airports, and hotels—are often when you're most vulnerable.

I'm not the neatest guy at home and around my office, but on the road, I'm meticulous. I never leave cameras, computers, lenses, or anything of value lying around the room. No matter how much of a hassle it is, I always pack this stuff up, put it back in my suitcase, and lock the bag. It's not that I don't trust the hotel staff, although anyone can be tempted. I want to avoid being the victim of "dippers"—bold thieves who walk in on housekeeping staff (usually cleaning a room with the door is wide open) and pretend to be the occupant, only to walk out with some of your gear. This is the most common type of hotel theft. (Think about the times you've walked into your own room when the house-keeping staff is cleaning; did anyone ever ask to see your key or ID?) While it's easy to grab a laptop or a lens and casually walk out

of a room, it's harder to be inconspicuous lugging a full-sized suitcase or duffle bag. Although it's hard to do when you're pressed for time and running in and out, it's a good idea to put all your stuff in a suitcase or duffel bag and lock that case before you leave the room.

There are some situations that call for even more vigilance. Chuck O'Rear, a *National Geographic* photographer and friend of mine, recounts an incident when he was shooting a story in Indonesia. He was staying in a beach bungalow in a very nice resort and woke up one night only to see someone leaning in the open window, attempting to fish out his camera bag with a long bamboo pole!

There's no doubt about it, there are places where even locking your bags isn't enough—you've got to lock them to something! This is where the PacSafe products come in handy (www.pacsafe.com). The mesh that wraps around your existing bags takes a little time to learn to use, but the PacSafe series of backpacks and duffels with the wire mesh and the cable built into the bag itself is much easier to work with.

On a recent assignment in Central America, there were a couple of places I didn't feel comfortable leaving my computer and peripheries in the room, even locked in the bag. So I took the laptop, auxiliary hard drives, and any extra bodies and lenses I wasn't using that day and put them in the PacSafe duffel, shoved it under the bed, and locked it to the bed frame.

Yes, it was a hassle, but not as much of a hassle as losing the gear! Finally, for one last bit of security, if the staff has cleaned the room already, I always leave a "Do Not Disturb" sign up and the TV or radio on so it sounds and appears that there is someone in the room. This minimizes hotel staff traffic through your room (i.e. the turndown service, the mini-bar guy, etc.) and may also discourage a thief looking to hit an unoccupied room.

Be Prepared, but Fear Not

All of these preparations and precautions may sound a bit obsessive, but in truth, they take little extra effort and can result in relatively stress-free travel. While several of my colleagues have been ripped off several times in their travels (outside of having one checked bag pilfered for a flash and a 50mm lens in Puerto Rico), I've been lucky enough to have traveled without theft or incident for 25 years. But keep in mind that "luck favors the prepared," and that seems to be the mantra of almost every successful location and travel photographer I know.

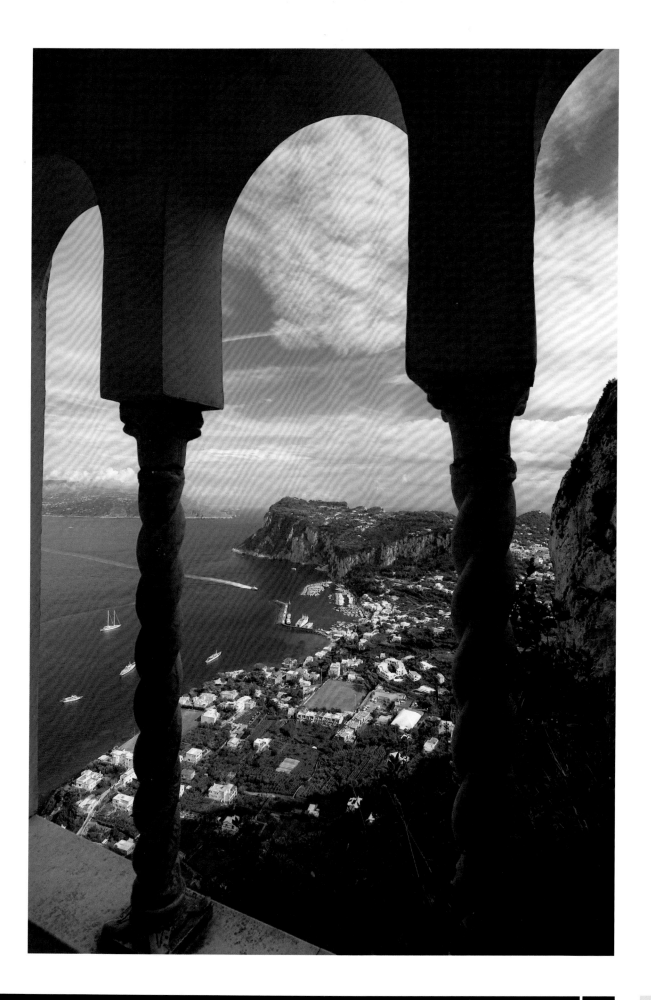

afterword

and no matter how good your technology is, it will not make up for a lack of vision, blown moment, or a lousy feel for light. This is why you often see so many technically excellent but utterly boring photographs on the sites of so many Internet experts with the best and latest of everything, while in places like Flickr, you can see some stunningly creative work shot by a kid with a cell phone camera and a good dose of photographic "vision."

Since going all-digital some five years ago, I've had plenty of pictures rejected by my stock agency and magazine picture editors— more than I'd like to admit. But none of them were rejected for "bad bokeh" or "soft corners" or "use of wrong RAW converter."
No, they were rejected for being too boring, or lacking moment, or bad lighting—things that have plagued photographers since the dawn of the Daguerreotype; in other words, bad field craft.

Yes, it's important that we stay abreast of the latest developments in digital photography technology, but don't let it become a full time job (or a full time hobby). It is easy to fall into the "magic bullet syndrome" as the constant barrage of software and hardware upgrades forces all of our attention to gear. Incremental developments are hailed as "revolutionary" and we so want to keep up with the photo Joneses and not be left behind that we gladly buy into the hype. None of us are immune to this; if I spent as much time researching stories and actually doing photography as I've spent upgrading, netsurfing, and reading about photography in recent years, my body of work—not to mention my sense of artistic satisfaction and accomplishment—would be huge.

So, the final bit of advice this book will offer is to get out there and shoot shoot shoot— don't sweat the megapixels. Great, timeless photographs have been made with equipment so primitive that they would be scorned on the Internet forums as mere toys. In the simplest of digital cameras, we have in our hands the technology capable of creating incredibly detailed, colorful images. It is up to us to make sure that our ability to see is at least as well developed.

Bob Krist
New Hope, PA

EXIF
Exchangeable Image File Format. This format is used for storing an image file's interchange information.

exposure
When light enters the camera and reacts with the sensitized medium. The term can also refer to the amount of light that strikes the light sensitive medium.

extension tube
A hollow ring, metal or plastic, that can be fitted between the camera and lens. It increases the distance between the optical center of the lens and the sensor and decreases the minimum focus distance of the lens.

FAT
File Allocation Table. This is a method used by computer operating systems to keep track of files stored on the hard drive.

file format
The form in which digital images are stored and recorded, e.g., JPEG, RAW, TIFF, etc.

filter
Usually a piece of plastic or glass used to control how certain wavelengths of light are recorded. A filter absorbs selected wavelengths, preventing them from reaching the light sensitive medium. Also, software available in image-processing computer programs can produce special filter effects.

FireWire
A high speed data transfer standard that allows outlying accessories to be plugged and unplugged from the computer while it is turned on. Some digital cameras and card readers use FireWire to connect to the computer. FireWire transfers data faster than USB. See also, Mbps.

firmware
Software that is permanently incorporated into a hardware chip. All computer-based equipment, including digital cameras, uses firmware of some kind.

flare
Unwanted light streaks or rings that appear in the viewfinder, on the recorded image, or both. It is caused by extraneous light entering the camera during shooting. Diffuse flare is uniformly reflected light that can lower the contrast of the image. Zoom lenses are susceptible to flare because they are comprised of many elements. Filters can also increase flare. Use of a lens hood, lens coating, or flare-cutting diaphragms can often reduce this undesirable effect.

focal length
When the lens is focused on infinity, it is the distance from the optical center of the lens to the focal plane.

focal plane
The plane perpendicular to the axis of the lens that is the sharpest point of focus. Also, it may be the film plane or sensor plane.

focus
An optimum sharpness or image clarity that occurs when a lens creates a sharp image by converging light rays to specific points at the focal plane. The word also refers to the act of adjusting the lens to achieve optimal image sharpness.

FP high-speed sync
Focal Plane high-speed sync. An FP mode in which the output of an electronic flash unit is pulsed to match the small opening of the shutter as it moves across the sensor, so that the flash unit can be used with higher shutter speeds than the normal flash sync limit of the camera. In this flash mode, the level of flash output is reduced and, consequently, the shooting range is reduced.

f/stop
The size of the aperture or diaphragm opening of a lens, also referred to as f/number or stop. The term stands for the ratio of the focal length (f) of the lens to the width of its aperture opening. (f/1.4 = wide opening and f/22 = narrow opening.) Each stop up (lower f/number) doubles the amount of light reaching the sensitized medium. Each stop down (higher f/number) halves the amount of light reaching the sensitized medium.

full-frame (FF)
The maximum area covered by the sensitized medium.

full-sized sensor
A sensor in a digital camera that has the same dimensions as a 35mm film frame (24 x 36 mm).

Gigabyte (GB)
A unit of computer memory just over one billion bytes (1024 megabytes).

gray card
A card used to take accurate exposure readings. It typically has a white side that reflects 90% of the light and a gray side that reflects 18%.

grayscale
A successive series of tones ranging between black and white, which have no color. Also, an image with purely luminance data and no chroma information.

guide number (GN)
A number used to quantify the output of a flash unit. It is derived by using this formula: GN = aperture x distance. Guide numbers are expressed for a given ISO film speed in either feet or meters.

hard drive
A contained storage unit made up of magnetically sensitive disks.

histogram
A two-dimensional graphic representation of image tones. Histograms plot brightness along the horizontal axis and number of pixels along the vertical axis, and are useful for determining if an image will be under or overexposed.

hot shoe
An electronically connected flash mount on the camera body. It enables direct connection between the camera and an external flash, and synchronizes the shutter release with the firing of the flash.

icon
A symbol used to represent a file, function, mode, or program.

image-processing program
Software that allows for image alteration and enhancement.

interpolation
Process used to increase image resolution by creating new pixels based on existing pixels. The software intelligently looks at existing pixels and creates new pixels to fill the gaps and achieve a higher resolution.

IS
Image Stabilization. This is a technology that reduces camera shake and vibration. It is used in lenses, binoculars, camcorders, etc.

ISO
From ISOS (Greek for equal), a term for industry standards from the International Organization for Standardization. When an ISO number is applied to film, it indicates the relative light sensitivity of the recording medium. Digital sensors use film ISO equivalents, which are based on enhancing the data stream or boosting the signal.

JFET
Junction Field Effect Transistor, which is used in digital cameras to reduce the total number of transistors and minimize noise.

JPEG
Joint Photographic Experts Group. This is a lossy compression file format that works with any computer and photo software. JPEG examines an image for redundant information and then removes it. It is a variable compression format because the amount of leftover data depends on the detail in the photo and the amount of compression. At low compression/high quality, the loss of data has a negligible effect on the photo. However, JPEG should not be used as a working format—the file should be reopened and saved in a format such as TIFF, which does not compress the image.

Kilobyte (KB)
A unit of computer memory just over one thousand bytes (1024).

latitude
The acceptable range of exposure (from under to over) determined by observed loss of image quality.

LCD
Liquid Crystal Display, which is a flat screen with two clear polarizing sheets on either side of a liquid crystal solution. When activated by an electric current, the LCD causes the crystals to either pass through or block light in order to create a colored image display.

LED
Light Emitting Diode. It is a signal often employed as an indicator on cameras as well as on other electronic equipment.

lens
A piece of optical glass on the front of a camera that has been precisely calibrated to allow focus.

lens hood
Also called a lens shade. This is a short tube that can be attached to the front of a lens to reduce flare. It keeps undesirable light from reaching the front of the lens and also protects the front of the lens.

light meter
Also called an exposure meter, it is a device that measures light levels and calculates the correct aperture and shutter speed.

lithium-ion (Li-ion)
A popular battery technology that is not prone to the charge memory effects of nickel-cadmium (Ni-Cd) batteries, or the low temperature performance problems of alkaline batteries.

lossless
Image compression in which no data is lost.

lossy
Image compression in which data is lost and, thereby, image quality is lessened. This means that the greater the compression, the lesser the image quality.

low-pass filter (LPF)
A filter designed to remove elements of an image that correspond to high-frequency data, such as sharp edges and fine detail, to reduce the effect of moiré and aliasing. See also, moiré and anti-aliasing.

luminance
The amount of light emitted in one direction from a surface. It can also be used as luminance noise, which is a form of noise that appears as a sprinkling of black "grain." See also, brightness, chrominance, and noise.

macro lens
A lens designed to be at top sharpness over a flat field when focused at close distances and reproduction ratios up to 1:1.

main light
The primary or dominant light source. It influences texture, volume, and shadows.

Manual exposure mode
A camera operating mode that requires the user to determine and set both the aperture and shutter speed. This is the opposite of automatic exposure.

Mbps
Megabits per second. This unit is used to describe the rate of data transfer. See also, megabit.

megabit
One million bits of data. See also, bit.

Megabyte (MB)
Just over one million bytes.

megapixel
A million pixels.

memory
The storage capacity of a hard drive or other recording media.

memory card
A solid state removable storage medium used in digital devices. They can store still images, moving images, or sound, as well as related file data. There are several different types, including CompactFlash, SmartMedia, and xD, or Sony's proprietary Memory Stick, to name a few. Individual card capacity is limited by available storage as well as by the size of the recorded data (determined by factors such as image resolution and file format). See also, CompactFlash (CF) card, file format.

Index